Things
I Didn't
Throw
Out

D0879591

Things I Didn't Throw Out

Marcin Wicha

Translated by Marta Dziurosz

This edition first published in the United Kingdom in 2021 by
Daunt Books Originals
83 Marylebone High Street
London W1U 4QW

1

First published as *Rzeczy, których nie wyrzuciłem*
by Wydawnictwo Karakter, Kraków, 2017

The right of Marcin Wicha to be identified as the author of the work has been
asserted by him in accordance with the Copyright, Designs and Patents Act 1988.

This publication has been supported by the Polish Book Institute's programme
SAMPLE TRANSLATIONS © POLAND

This book has been selected to receive financial assistance from English PEN's
PEN Translates programme, supported by Arts Council England. English PEN exists
to promote literature and our understanding of it, to uphold writers' freedoms
around the world, to campaign against the persecution and imprisonment of writers
for stating their views, and to promote the friendly co-operation of writers and the
free exchange of ideas. www.englishpen.org

A CIP catalogue record for this title is available from the British Library.

ISBN 978-1-914198-02-1

Typeset by Marsha Swan
Printed and bound by TJ Books Ltd, Padstow, Cornwall

www.dauntbookspublishing.co.uk

Things
I Didn't
Throw
Out

Introduction

This is a story about things. And about talking. That is – about words and objects. It's also a book about my mother, and so it won't be too cheerful.

I used to think that we remember people for as long as we can describe them. Now I think it's the other way around: they're with us for as long as we don't know how to pin them down with language.

It's only dead people that we can make our own, reduce to some image or a few sentences, figures in the background. Suddenly it's clear – they were like this or like that. Now we can sum up the whole struggle. Untangle the inconsistencies. Put in the full stop. Enter the result.

But I don't remember everything yet. As long as I can't describe them, they're still a little bit alive.

Forty years ago – and I don't understand why this particular conversation lodged itself in my memory – I was complaining about some dull educational programme on Polskie Radio, and my mother said: 'Not everything in life can be turned into a funny story.' I knew it was true. But still I tried.

MY MOTHER'S KITCHEN

The estate

She never spoke about death. Just once. A vague hand movement, a wave towards the shelves:

'What are you going to do with all this?'

'All this' meant one of those shelving systems you buy at IKEA. Metal runners, brackets, planks, paper, dust, kids' drawings hung up with drawing pins. Also postcards, mementoes, wrinkled little chestnut people, bunches of last year's leaves. I had to react somehow.

'You remember Mariuszek from school?'

'A lovely boy,' she said, because she remembered I didn't like him.

'A few years ago, Marta and I visited his mother-in-law to bring or take something, something for kids, a playpen or what have you.'

'How many children does he have?'

'I don't know, but the mother-in-law spoke very highly of him. She said that when her roof started leaking, Mariuszek paid to have it replaced, in bituminous tile, all very expensive, and he told her: "Don't you worry about money, Mummy, it will all stay in the estate."'

'So how is he doing?'

'I don't know, he works at a law firm. Don't worry about the estate. There's still time.'

But there wasn't.

My mother adored shopping. In the happiest years of her life she'd set off to the shops every afternoon. 'Let's go into town,' she'd say.

She and my father liked to buy small, unnecessary things. Teapots. Penknives. Lamps. Mechanical pencils. Torches. Inflatable headrests, roomy toiletry bags, and various clever gadgets that might come in useful when travelling. This was strange, as they never went anywhere.

They would trek halfway across town in search of their favourite kind of tea, or the new Martin Amis novel.

They had their favourite bookshops. Favourite toyshops. Favourite repair shops. They struck up friendships with various – always very, very nice – salespeople. The antique shop lady. The penknife man. The sturgeon man. The lapsang souchong couple.

Every purchase followed the same ritual. They would notice some extraordinary specimen – in the shop that sold

second-hand lamps, for example, where the lamp man held court, a very pleasant citizen, to use my father's jaunty phrase.

They would have a look. Ask about the price. Agree they couldn't afford it. They returned home. Suffered. Sighed. Shook their heads. Promised themselves that once they had some money, which should happen soon, they really must . . .

In the days that followed they would talk about that unattainable lamp. They wondered where to put it. They reminded each other it was too expensive. The lamp lived with them. It became a part of the household.

My father talked about its remarkable features. He sketched the lamp out on a napkin (he had excellent visual memory), pointing out how original certain solutions were. He stressed that the cable had textile insulation, barely worn. He praised the Bakelite switch (I could already see him taking it apart with one of his screwdrivers).

Sometimes they'd decide to visit it again. Just to have a look. I suspect it never occurred to them to bargain. In the end, they'd make the purchase.

They were perfect customers. Kind-hearted. Genuinely interested in new merchandise. Then my father tried a sample of the green Frugo soft drink in a shopping centre and had a heart attack. We had a little time to joke about it. Even the doctor at A&E thought it was funny.

A thin trickle was all that was left after they were both gone. The TV remote. The medication box. The vomit bowl.

Things that nobody touches turn matt. They fade. The meanders of a river, swamps, mud.

Drawers full of chargers for old phones, broken pens, shop business cards. Old newspapers. A broken thermometer. A garlic press, a grater, and a – what's it called? – we laughed at that word, it featured in so many recipes for a time: a quirl whisk. A quirl whisk.

The objects already knew. They felt they would be moved soon, shifted out of place, handled by strangers. They'd gather dust. They'd smash. Crack. Break at the unfamiliar touch.

Soon nobody will remember what was bought at the Hungarian centre. Or at the Desa gallery, the folk art stall, the antique shop – in times of prosperity. For a good few years, tri-lingual Christmas cards would arrive from businesses, always featuring a photo of some plated trinket. Eventually they stopped. Maybe the owners lost hope of further purchases. Maybe they closed down.

Nobody will remember. Nobody will say that this teacup needs to be glued back together. That the cable needs to be replaced (and where would you find one?). Graters, blenders and sieves will turn into rubbish. They'll stay in the estate.

But the objects were getting ready for a fight. They intended to resist. My mother was getting ready for a fight.

'What are you going to do with all this?'

Many people ask this question. We won't disappear without a trace. And even when we do disappear, our things remain, dusty barricades.

Until

'This is supposed to be me? Well, if that's how you see me . . .' She didn't receive handmade greeting cards easily. She wasn't an easy model. In fact, with her nothing was easy.

Polish homework in Year 4: 'Describe your mother', or rather 'mum', because the school relished diminutives. God, forgive me, because I wrote: 'My mother has dark hair and is rather stout.' Children have a different concept of weights and measures.

The Polish teacher weighed a hundred kilograms and underlined the phrase 'rather stout'. She pressed the ballpoint pen down so strongly that she ripped through the paper. On the margin she carved the words: 'I wouldn't say that.' My mother rarely agreed with the education system, but that pleased her.

—

She also had what respectable compatriots called 'ahem'. Let me repeat: 'respectable'. Less respectable ones had no difficulty with pronunciation.

There was something disconcerting about the ostentation of her features. She had the, ahem, look. The look of someone of, ahem, ahem, descent. What descent? Ahem. Upf.

There should be a special punctuation mark. A graphic equivalent of a contraction of the larynx. The comma won't do. The comma is a wedge for catching your breath, and what's needed here is a typographic knot, bump or stumble.

It's a tough thing, having that look. An acquaintance of mine used the phrase: 'N. is not dissimilar in appearance to Jerzy Kosiński.' But N. did not have to resemble the famous writer at all. He could be, say, a short, tubby, good soul without the riding breeches or whip which Kosiński sported on the cover of the *New York Times Magazine*, and still be equipped with obvious ahem.

In keeping with this terminology, my mother was also not dissimilar to Jerzy Kosiński. 'I'm an old Jewess now,' she said one day in 1984. In fact, she was younger then than I am today. But yes. She had ahem. Ahem for days.

When she died, people wrote to say various nice things. An eminent friend recalled that in her youth she'd been an excellent student. People foresaw a future in academia for her. Everyone expected her to stay at university.

But she spent her whole life in career counselling in Muranów. Her counselling service moved from place to place around the district, and finally settled in a building right on the Umschlagplatz (where there were many problems with the historic buildings conservation officer).

And so she worked on top of the invisible rubble of the Warsaw ghetto. Wearing the standard-issue white coat – her surname had been written on the front but the marker ink dissolved in the wash – she would give children boxes filled with clever puzzles. Tests bearing the names of German professors. Mazes. Locks with catches. Holes in geometrical shapes. Decks of picture cards. Trick questions for assessing general knowledge. Think carefully: which picture doesn't match the others? You've got plenty of time. Tick tock – the stopwatch chivvied them along.

In the spring, she informed pained young ladies who had failed their high school entry exams that there were still places in the tractor-building technical college in Ursus.

For most of the year she was something of a court-appointed attorney. A one-person committee for saving the unfortunates mauled by the education system. Defence counsel for children at the edge of the norm who got beaten up every year of their school-time ordeal. Guardian of persistent truants. Of the poor wretches with such bad handwriting and spelling problems that nobody – apart from my mother – noticed that they were impressively knowledgeable about explosives, samurai swords and Field Marshal Paulus.

———

In 1987 she was at war with a monstrous teacher of chemistry, or biology or something. The teacher was part of the Warsaw pedagogical elite and had many an adolescent's depressions, neuroses and suicide attempts under her belt.

While talking to the teacher about one of her patients, my mother said: 'You are ruthless, madam.'

'You have such a rich vocabulary,' a friend praised her when she recounted the story later.

'I have to talk like that,' mother explained. 'After all I can't tell the stupid bitch that she's a stupid bitch.'

She terrorised people, telling them the truth to their faces. She would not be silent when it suited others for her to be silent. She didn't react to our shhs, our give it a rests or not so loudlys.

Lots of people said she was strong. I don't think she was, but she did despise helplessness. She kept *Medication in Modern Therapy* on her shelf (so as not to depend on a doctor). She had a hundred cookbooks. A notebook with a million phone numbers for every possible requirement. At the turn of each year there was a nervous search for refill pages, difficult due to the absolutely non-standard arrangement of the holes and rings in her binder. Finally the search would succeed and the notebook would swell with new pages, until eventually the press stud on the strap refused to snap shut.

As Don said in the third *Godfather*: 'The richest man is the one with the most powerful friends.' I think he meant the washing machine repairman and the doctor who gives out their private number.

She taught me that friends are more important than family. That one can really only count on one's high school classmates.

She would also make a fuss at the newsagents. She made the shopkeepers remove the promotional flyers from *Gazeta Wyborcza*. Faced with resistance, she would shake the newspaper herself and a rain of leaflets, price lists of electrical goods, discount coupons and samples fell out from between the pages.

She was especially irritated by brochures like *Saints and Miracles. Part Four: Levitation, Bilocation, Healing*. She was also pitiless towards the cyclical anthology of pilgrimage sites.

'But you won't die?' I asked her once.

'I will. Everyone dies.'

'But you won't?'

'I will, but only when you don't need me any more.'

I was five, and at first considered this answer satisfactory. Negotiations around death are not easy. I achieved what was possible within the current circumstances, as trade unionists say. I didn't understand until later that this was her condition. 'Only when you don't need me any more.' Unneeded, she languished. One hundred per cent Jewish mother.

Stones

Heavy, brown, almost black, its shape brought to mind a lump of butter. There was an object like this in every household; in the summer it weighed down the lid of the stoneware jar filled with pickled cucumbers, dill and garlic. My mother's stone.

Father's stones were useless. He particularly liked pebbles. With pale convex veins. Or red and porous. Or white. Dark grey.

Geology did not interest him. He could identify flint, granite, limestone with shells embedded in it. Sandstone for elevations, marble for headstones, grit for lining paths. But he was one of those people who would watch where they're walking, incapable of indifference towards a perfect form. At the seaside he collected pieces of glass and shards of porcelain. He could never pass by a chunk of water-smoothed brick without picking it up. A brick pebble, co-produced by man and nature. He enjoyed that.

He carried them in his pockets. He brought them home from holiday, and then, for want of a better idea, poured them into my mother's plant pots. In our house, unfortunate rubber plants grew out from between miniature cobblestones. Sharing, on a smaller scale, the sad fate of city trees.

They didn't argue about this. They rarely argued at all. They were like two opposing forces. Tectonic plates pushing against each other. Mother complained. Father staked claims. They marked out their positions and remained in equilibrium. At times – some lava, some ash.

After he died, she kept taking care of her plants. She bought fertiliser and aphicide spray from the florist. Before going away, she fitted them with drips with a ceramic drain, so that they were watered gradually, drop by drop. But the water struggled to reach the root system because my mother never got rid of the cobblestones.

Occasionally, she would select a particularly beautiful pebble and take it to my father's grave. She would, however, immediately fill the gap with a new find. If the geranium and the hoya hoped for a thaw in the regime after my father's death, they were sorely disappointed.

Rubbish

The book buyers are happy, the book sellers suffer.
– Yuri Trifonov

And now she's dead. I'm sitting in her flat. Everything's gone. Only the books are left.

They were our background, featured in every frame. I had known their spines before I discerned letters in the black symbols. I've told fortunes with them my whole life. Looked for punchlines.

First, I try calling friends.

Attempt number one.

'We thought you might want to . . .' The plural 'we' is calculated to suggest a long family discussion, something along

the lines of 'the executors of the will would like to entrust', or 'who else could possibly take over'.

'Maybe you'd like to see them, there are lots of psychology books —'

'No way.'

'At least take a look?'

'We've run out of space for books. Anyway, Zygmuś and I have agreed that every time we buy a new one, we have to get rid of an old one.'

'But who said anything about buying?'

'No.'

Attempt number two.

'I know my mother would've wanted you to —'

'No.'

Attempt number three.

'There are some books here that I think belong to you. I'd like to return them. And is there anything else you'd like? Some crime books?'

'I don't read crime any more.'

Attempt number four. A glimmer of hope.

'We have to get rid of the books.'

'Have you got anything on Jews, but with no Holocaust in it?'

'Want the New Testament?'

—

Second-hand bookshop. Search, Google, search!

'Nationwide. Good prices.' No answer.

'No call-out fee. Quick evaluation. Cash.' No answer.

'We travel and buy.' Someone picks up. Says they don't travel and they don't buy.

Finally, success.

'I have to get rid of some books,' I begin. I overcome the temptation to explain why. I'm not going to explain anything. I just want them to disperse. Scatter like the letters from the bank that my father methodically tore into pieces. Bricks from a demolished building. Organs for transplant.

'I have books to get rid of. There's quite a lot of them.'

'When?' asks the antiquarian.

'Within the week.'

'Might as well forget it. I'm busy for at least the next two weeks.'

'Two is all right. Lots of fiction. Novels from the nineties. Nice editions . . .' I say slyly. 'Published by Rebis . . .'

'I know those.'

'. . . but there's also the four-volume encyclopaedia from PWN,' I add. I don't say that it's from the era of martial law and that the bindings don't match.

'That's rubbish, I can tell you that right away.'

'There are also various how-to books.' I don't mention *The Anti-Cancer Diet*. It turned out to be worthless.

'Rubbish.'

'Dictionaries?'

'Rubbish.'

I feel ashamed to look at the two volumes of the Stanis-
ławski dictionary.

'Any Polish classics?' asks the antiquarian cannily. 'Sien-
kiewicz? Reymont? Żeromski?'

'Nothing at all,' I lie. 'Well, maybe something by Prus.'

'Rubbish! Orzeszkowa – rubbish. Dąbrowska – rubbish. I
don't even buy those any more.'

Somewhere on the top shelf there are remnants of
Prus: *Emancipated Women*, a piece of *Pharaoh*, bits of *Weekly
Chronicles*.

Collected works always look like an army. But now the
green canvas is worn, faded and dirty. A fragmented unit low
on morale. 'Hey now, willow, hey now, weeping one, your sad
murmur follows where he's gone . . .' Once, a guard regiment
of Pushkin in navy covers was stationed there. Now only
volume XIV remains, pardoned for obscure reasons.

'No Prus!' I lie.

'If you box it up, I can take it and have a look,' the anti-
quarian relents.

What else can I tell him? The guy buys book collections. Real
collections are donated to libraries or museums after their
owners die. All I have left are books. We'd never have used
a different phrase for them. It's like parlour and living room.
We kept our books in the living room.

Trendy novels that stopped being on trend. Reading that wasn't required. Selected volumes from collected works. Peace without war. The beginning of *Howards End*. Incomplete diaries. Forgotten debuts. Unopened volumes of essays.

And a fascinating book about Lindbergh's plane – thirty years ago I wheedled it out of my mother at the bookshop on Dąbrowskiego Street, because I was delighted with the technical drawings of the Spirit of St. Louis (they even showed the propeller's diameter). Perhaps I believed for a moment that I would become a modeller. I managed to convince my mother, although she was sceptical about my plans. She said: 'I'll buy you any book. At least you're not an idiot.'

Our bookshelves are a record of our failures as readers.

How few are the books that we really liked. Even fewer are the ones we like on rereading. Most of them are souvenirs of the people we wanted to be. We pretended to be. We thought we were.

Covers

Books from the forties are big in size. Brown, greenish, beige. Earth and shoddy printing tones. Limp cardboard covers that seem half a size too big. They crumble. I try to be careful, but they shed bits of paper anyway.

The classics. Now I'm wondering whether I should pardon the last ones: Dickens, Zola, Turgenev, something with no cover but bearing the words, 'Complimentary annual copy for the subscribers of KDK'.

Reconstruction was under way. Mateusz Birkut laid bricks in Wajda's film *Man of Marble*. Czytelnik's printing houses were working at full steam. People needed something to replace the ash. They needed paper walls. Pushkin, Romain Rolland, socialist realist novels, everything.

I remember the grass-green fence of Balzac in my grandparents' house. The imposing palisade of *The General History*. The Chinese wall of the *Great General Encyclopaedia*.

Then a change comes. The small, affable volumes published by Iskry appear. Chillers, whodunnits, a striped *Catcher in the Rye*, Truman Capote with black and white drawings by Młodożeniec.

The Nike book series era was approaching. The geological cross-section of our shelves shows their colourful volumes. They mark the sixties layer.

Today the spines have faded. Pink beige, greenish beige, blue beige, they're all watery like a centenarian's eye. But when I reach for them, it turns out that the front covers have retained their hue. The old cover of a book by Vercors flashes purple before it vanishes in a box.

Small formats for small flats. The social and political 'minor stabilisation'. The Mikrus microcar, the truncated Duchy of Warsaw. Lyrics from the TV show *Old Gents' Cabaret*, full of miniature props and characters, petite ladies, little old ladies, little young ladies. There was also 'a slip of a man'. And: choo choo train stations, the wee small hours, tootsies and slipperettes, yearnlings, modest love, a tiny wisp of feeling.

At the end of the decade my father shortened the legs of a coffee table by the Ład artists' cooperative. He did so with precision, the dachshund landed on its feet and stood there solidly for years (what do I do with it?).

My parents in their first small flat. They look slight and childlike in the black and white photographs. Later they got bigger. Gained weight. Went grey. Worked. Strove. They were responsible, sometimes committed, but never fully grew up. They never came to resemble the elders – their parents – as if somewhere inside they kept a sixties sense of scale.

'70s

Portraits are used on banknotes for pragmatic reasons, said Andrzej Heidrich, who designed our currency. Portraits are the most difficult thing to forge. A tiny inaccuracy, a tad more pressure on a line, a different curve of an eyelid – and the fake hero's expression changes.

The radial lines around the Ewa Reactor on the Marie Curie banknote. Circuits of planets tracing Copernicus's secular halo, banners, generals' braids, musical notation – those are just small additional impediments.

Generally, we recognise a banknote by its gaze. There's something alien in the features of a counterfeit face.

This is why an alert cashier would raise the paper to his eyes. He would look for General Walter's piercing stare (but not piercing enough to spot the Ukrainian insurgents who would ambush his soldiers). Or the myopic eyes of Ludwik Waryński. The glare of Stanisław Moniuszko, seemingly slightly unnerved by the approaching cavalcade of zeroes on the 100,000 złoty note.

Heidrich was also head designer of the eminent publishing house Czytelnik. There were no portraits on his covers.

Every object and figure looked like an emblem. Ornaments entwined in the background.

In their reticent way, Heidrich's designs could be amusing or sentimental.

He wasn't selling anything. He established hierarchies. He was the national bank of Polish literature. Jarosław Iwaszkiewicz was the highest denomination. Next there was the fully convertible Ryszard Kapuściński. Then Tadeusz Konwicki. Julian Stryjkowski. Foreign literature. Joseph Roth. Henry James, E. M. Forster.

It was solid currency. It had an established, official exchange rate. Until the crash came.

'80s

Paper shortages. A euphemism. One of those expressions that was always around then, in those difficult times.

Paper shortages affected the Catholic press. Paper shortages meant that books waited for years to be printed. Paper shortages – they were why I had to carry stacks of old newspapers to a collection point. A man with cut-off ears threw the papers onto a scale. Then he wrote a receipt. 'Whoever doesn't bring their receipt to prove they don't waste paper won't get their report card,' they warned at school.

The hunt for toilet paper. The hunt for cotton wool. Drawings on greaseproof paper scrounged at the dairy. Grey notebooks. Queues for drawing pads. Applications for rationed reams. The microscopic formats of underground newspapers.

In the eighties the shortages reached their zenith. This was when zebra books appeared. Each section was printed on a different sort of paper. The edge looked like white, yellow and grey geological layers. 'They did this on purpose?' my kid asked, seeing a volume of Hłasko.

It wasn't until the era of transformation that everything lit up. Books glowed. Leaflets reflected sunbeams. For a long time after 1989 it was still the done thing for a leaflet, poster or brochure to emphasise its white paper. White and glossy was best. In a TV ad, a polite man assured us that white could be even whiter. Shirts, tablecloths and teeth were given a white wash.

'90s

First the black series from PIW. Dozens of black, gleaming spines. The publisher couldn't decide whether the title should be written upwards or down. The mixed-up titles gave our shelves some variety. And then the nineties arrived and my parents started buying novels published by Rebis.

Rebis titles had bright, photographic covers. The era of stock photography was not with us yet. Instead someone dutifully arranged collages of colourful Fabriano paper, scraps of fabric, marbles, foreign maps, fake leaves or cocktail umbrellas stuck into sand, later covered with a layer of shiny laminate.

They looked cool. Before, there were disciplined rows of officials in black suits. And then suddenly: a bunch of contented hippies. A great summer holiday started on our shelves. My parents didn't travel anywhere. They bought books.

'Is it any good?' I would ask, sceptical.

'Mhm,' said my father, 'four hundred and seventy-two pages.'

When buying records, he also always checked the running time. Seventy-seven minutes of Glenn Miller: a very good album.

'Besides, they write good things about it,' he added as an excuse.

'Where?' I asked, because I was young.

'On the cover,' he replied.

Indeed. There was a black box underneath the title. Small italics assured us: *'Witty and surprising.' The Times.* Sometimes there were names of literary prizes we'd never heard of ('Tandoori Prize for the Best Debut of the Year', 'Joe Doe Prix 1992').

If reviewers couldn't bring themselves to say anything good, the quotation marks disappeared. The words in the box stated that we had in our hands the author's best novel (since their previous book).

All this dispelled my parents' qualms. The colourful shelf grew. The nineties carried on merrily.

I dust the books. The microfibre cloth resembles a towel. There, there. You'll be warm again soon. Everything will be all right (and bam, into the box).

How

She, he, they 'presented with anxiety'. She liked using professional jargon. Sirens wailed somewhere. A door banged shut. A crash. High levels of anxiety, she'd say.

Professional jargon was really something. I remember a grey-haired professor, one of my mother's pre-March '68 teachers, who made a throwaway comment while telling a story about Kafka: 'Pretty disturbed too, by the way.' She finished the guy in six words. With a verbless sentence. The particle 'too' put him in a long queue of similar cases. Poor Franz.

Pretty disturbed too – that was when I understood what made my mother choose her profession. Because she always talked like that. Matter-of-fact. No sentimentalising. Maybe she learned that at university. High levels of anxiety. Low mood. Limits of the norm on a bell curve.

My mother kept adding to her professional library until the very end. At the top of the bookshelf sit greenish and dirty pink volumes. Covers gloomy like the waiting room of a mental health clinic. My mother's interests are summed up by the following titles:

Anxiety
Anxiety, Anger, Aggression
Melancholy
Schizophrenia
Sexual Violence

She could be meticulous about arranging books, so the spines create stories, at times not without irony.

Introduction to Psychoanalysis
The Psychoanalytic Revolution
Psychoanalysis
Twilight of Psychoanalysis

The word 'development' recurs in the titles. (How's your development in the current five-year plan?) Developed. Underdeveloped. Retardation of development. A horrible word which haunted schools. An accusation and a judgement. 'Retarded!' screamed teachers. 'You'll go to a special school.'

The Psychological Development of Children
The Development of Moral Judgement in Children
Disorders in Adolescence
Intelligence, Will and Capability to Work
Youth and Crime

Looking at this set of titles, one can imagine a frustrated, not especially intelligent teen who fails to take up work at a factory, succumbs to bad influences – undoubtedly as a result of underdeveloped moral judgement – and finds himself in juvenile court.

On the lower shelves, the era of colourful paperbacks begins. My mother assembled a whole little corner of books about the happy body, liberated soul and vanquished sense of guilt. But first you had to get rid of the poisons ('toxic' wins the poll for adjective of the decade):

Toxic Parents
Toxic Family
Toxic Work
Only Children (I was unsettled to see that she put *Only Children* in that particular place.)

Next, a gem:

Toxic Love and How to Free Yourself from It

The nineties were the realm of the adverb 'how'. After the fall of communism, everything became possible. The problems catalogued in dusty tomes finally had a cure. The solutions were ready. You only had to know how:

Depression and How to Overcome It
How to Save a Relationship
How to Raise a Happy Child
How to Control Your Anger Before It Controls You
How to Live a Happy Active Life Despite Anxiety
How to Help
How to Talk
How to Listen

Communism had been an exercise in the art of continuity. Preserve the capital. Don't squander what you're given. Remain a decent person. Under capitalism, individuals must master the art of change. How to exercise the mind, the muscles; how to shed the kilograms; be a better father, a conscious consumer, a healthy corpse. The following spines radiated optimism:

The Safe Home
The School for Pupils
The School Without Anxiety
At Peace with Yourself and Your Pupils
Life-Enriching Education
A Good Enough Parent

The last book, I discover, is a story inspired by the animated series *Clifford The Big Red Dog*. It looks like it was waiting, stuffed in between depressions and eating disorders, for her granddaughters to visit. She'd thought of everything. I even find a small book entitled *How I Emptied My Parents' House*. I set it aside.

Children's books

She was an outstanding grandma. An expert on specialist Lego vendors. A regular of hobby shops selling the widest range of puzzles, educational building blocks and jigsaws suitable for her granddaughters' ages.

It only took a generation for the shabby test cards with which she tormented me in my boyhood to transform into friendly, colourful toys for my children.

Her favourite toyshops went bankrupt one by one. She escorted each of them to their eternal rest. During the final closing-down sale she would take over the remainders of stock and then leave the empty establishment.

Sometimes – trying to prevent their own downfall – the shop owners gave up on their ambitions to sell items of quality and attempted to sell junk instead. She would then boycott them and look for another merchant with a gene of self-destruction.

She was a discerning reader of children's literature. Her shelves held a collection of beautiful and valuable publications. Richly illustrated books about gay penguins, bear cubs with borderline personality disorder, rabbits whose warrens were ravaged by war. Books about refugee squirrels. Books with a grey background, a cloudy sky, an uncompromising lack of colour (palette: autumn in Lugansk).

She could also appreciate real kitsch. Mice at ballet school, for example. Featuring dazzling hyperrealistic illustrations with myriad details – illustrations that you could look at for hours, trying to make out the smallest props until you finally discovered, hiding in the shadows, a tiny frame that contained a daguerreotype of a rodent great-grandfather with sideburns and a clay pipe, printed on which – unbelievably – there was a painting of a minuscule mouse, dressed in his uniform for the Battle of Mausterlitz.

'I'm working on my immortality,' she'd say. She was composing others' memories so that one day the children would realise that the hours spent in her flat, among illustrated books and films on VHS, were their only moments of perfect calm. That this was the only safe place. Perhaps she wasn't wrong.

Who will comfort

I remember the autumn when we were buying *Who Will Comfort Toffle*. It was one of Tove Jansson's minor works, a slim book with many illustrations. Apart from the title, I can't remember anything about it.

But back then my mother and I would set out every afternoon to the bookshop in the new building on Madalińskiego Street. Today it is no longer new and some bank, pharmacy or mobile phone operator has probably moved in.

One of the shop assistants seemed more sympathetic than the others. My mother sensed these things unerringly. She could always find the staff's weakest link.

And so, day in, day out we walked, wading in poplar leaves, to ask the ritual question:

'Have you got *Who Will Comfort Toffle*?'

We weren't expecting the affirmative at all. Had Toffle appeared in the morning, he would have been sold instantly.

He would have disappeared from the shelf before we'd left work (in my mother's case) or school.

Why, then, did we spend weeks coming up to the counter and repeating our line? Well, we were conducting a long-term programme of mollifying the bookseller. We had to convince her that we cared; we wanted Toffle more than anyone else in the area. We deserved him more than the feather-brained nephew of a friend who worked at the butcher's, even if Toffle was to be bartered for a certain number of frankfurters or whatever meat was available. And definitely more than the damned pensioners loitering around in the mornings and snatching up attractive recent publications.

We had it in for one of them in particular. He wore a suit, had a comb-over and lavished the bookseller with suggestive compliments. He went so far as to propose to her, and provide her with ersatz chocolate. It wasn't clear why he wanted *Who Will Comfort Toffle*. Perhaps he promised it to the sales assistant at the sweet shop? That would have created a closed circuit of goods.

Even transport guards working for the distributor, Dom Książki, were a threat. Every morning they delivered all the new releases and, naturally, they stole what they could. My parents' friend defended one of them in court.

'If I get less than five years, my whole book collection goes to my lawyer,' declared the accused.

'Fat chance. They all say that,' muttered the lawyer's wife while I imagined the guard's library, full of rare editions and precious volumes, with Toffle in pride of place.

—

My job was to make sure the shop assistant was moved, while my mother struck up a sort of conspiracy with her. All to one end.

One day they would finally deliver Toffle. And the bookseller would remember our perseverance. She'd think: 'All right, all right, they've waited so long', and stash one copy under the counter. She'd risk the queue's revenge, professional consequences, exile to Siberia. She'd do it for us! For that nice boy and his dark-haired mummy.

My mother orchestrated this plot in good faith. She wanted to convince me that the world will not deny us something we really want. To each according to their needs, provided we can justify and demonstrate such a need convincingly.

I always ran ahead. I burst into the bookshop out of breath. I shouted 'Good morning!' at the door – I never forgot the courtesies – and then, more discreetly, in a lowered voice:

'Have you got *Who Will Comfort Toffle?*'

'No,' replied the bookseller.

The breakthrough happened in November. I arrived at the counter, but before I could open my mouth, the sales assistant said:

'No, nobody will comfort Toffle today.'

My mother and I decided it was a good sign. The bookseller remembered us. She'd made a joke. We were definitely on the right track. The thing now was not to doubt, not to lose patience.

Temperatures fell below zero. We made our afternoon treks in the dark. On the way, I stomped on frozen leaves and thin ice over puddles. Finally, the day came.

'HaveyougotwhowillcomfortToffle?' I asked my routine question.

'We had it yesterday,' answered the bookseller. Not a muscle moved in her face.

This was a blow. It had nothing to do with Tove Jansson. I felt I was a moment away from understanding something important about the world, about justice and promises. The ground started to give way under my feet, I felt this futility perhaps for the first time – and I reacted in the only way I knew how. I ran to my mother.

'They haven't got it!' I shouted. 'They had it yesterday.'

'Mhm,' she nodded, imperturbable. 'Let's go.'

'Where?'

'To get Toffle,' she answered.

'They had it yesterday,' I repeated dully.

'Yesterday was Sunday,' she said, and walked into the bookshop.

A moment followed – as it sometimes does – when every obstacle moves aside like automatic doors. Click. The bookseller discreetly passes us a bag. My mother pays. We leave happy.

Mummy Austen

It was a sweet view ... English verdure, English culture, English comfort, seen under a sun bright, without being oppressive.

– Jane Austen, *Emma*

This copy of the book is no longer in the 'condition: good' category, even if the note 'slight tearing and smudges' had been added as a compromise. I would see people trying to sell scraps like this in second-hand bookshops. Shabbily dressed tramps hauling loot from nearby rubbish bins. Teenagers reaching into their backpacks for *Your Year at the Allotment* stolen from grandma.

'And this?'

The owner just shakes his head.

'Can't give more than a złoty for this.'

A sigh of disappointment. The vision of a can of beer vanishes. Hesitation.

'All right then.'

So let's not sugar-coat it – condition: poor. No front cover. A stain on the back. Loose pages in the middle. Damaged spine. Numerous tears, creases, dirt. The paper falls apart when handled.

On page 27, on the inner margin, there's a drawing of a heart behind bars or just an unconsciously scribbled combination of parallel and curved lines (the owner was a psychologist).

On page 155, another doodle – a miniature envelope or a sunken destroyer from a game of Battleship.

This surprises me a little. I never saw my mother damaging books like this. Then again, she probably never discovered the black outline I gave Tadeusz Kotarbiński's portrait in PWN's *Small General Encyclopaedia* in 1983. I used a Pentel felt-tip pen. The shiny ink sank into the paper. I didn't understand what force compelled me to do that to the author of *Praxiology: An Introduction to the Science of Efficient Action.* I still don't.

I didn't find any more drawings in the Austen, but I did discover a minuscule hole burned through page 162. Perhaps it's a memento of a power cut. It's hard for me to imagine her reading *Emma* by candlelight. My mother never smoked, but she could have lent the book to a smoker friend (marital crisis? Work problems? Something health-related?). If that's what it was, the smell of smoke has long disappeared.

She treated this novel as therapy, returning to it in moments of unhappiness. During illness. At times of depression and historic catastrophes. She bought *Emma* in 1961, I gather from the publication date, and in the fifty years that followed she must have reread it a few dozen times.

Emma was a warning sign: Caution, bad mood. A hoisted black flag. A pile of apples, some tissues, a damaged book.

* * *

The cover went missing a long time ago. I vaguely remember it featuring women in long gowns and bonnets, colourful little prints (Jerzy Jaworowski didn't exert himself particularly on that one). At the beginning of the 1960s Polish publishing houses were not in the habit of printing blurbs. Today the copy dashed off by someone in the publicity department would sound like this:

> The classic novel. Amorous adventures in the English countryside. Witty, beautiful and rich Emma Woodhouse believes in her matchmaking talents. But the hearts of those closest to her hide many secrets, and her own feelings will surprise her the most. Meet the lively Miss Woodhouse and her circle of friends: stern Mr Knightley, humble Harriet, reticent Jane Fairfax – and the unique Mr and Mrs Elton.

* * *

Emma is like *Winnie-the-Pooh*: a group of fundamentally good-natured but flawed characters wander around a rural area.

They pay each other visits and talk. Chat. Blather. Converse. Material worries aren't of primary importance. Piglet will always find acorns. Pooh empties the last jar of honey with trepidation, but in the next chapter the larder is full, so everyone ambles off to play Poohsticks.

As well as the economic stability, the very rhythm of *Emma*'s sentences are calming. 'Ah, they know how to turn a phrase,' we say with satisfaction. Turn a phrase: this means that the text is constructed from sentences so long and complicated that the reader – thinking no more of meaning – marvels instead at how the author, that brave tightrope walker, proceeds, juggling modifiers, but look, they're about to fall, whew, they've regained their balance and triumphantly, they reach the full stop. Applause.

But the sentences in *Emma* don't try to prove anything. In no rush, they carry participles ready to stop the plot's course and spill out into a short digression. Add an ironic remark of a general nature, while the main current remains lucid and clear. Of all the books I know, this one most resembles a brook (in the Hundred Acre Wood, naturally).

But my mother was not the sort of person who would spend half a century seeking solace in the babbling of a brook. Beneath all appearances hides a book that is hardly good-natured. The interjections, succinct descriptions and pithy

comments add up to a clear image of Jane Austen. And compared to this lady our pal Nabokov seems like a cheerful, fun guy. A cool dude who would gladly knock back a few cans of lager with us on the banks of the Zegrze Lake.

Why does it bother us when somebody uses the word 'stationary' when they mean 'stationery'? When bombarding friends with holiday photos online, what's wrong with stating that Kyoto is the 'ancient capital of Japan' and then, after a moment of deliberation (revealed by the indiscreet 'show edit history' option), changing it to the 'ancient capital of Nippon'? Do we have the right to judge others for the pet names they call their loved ones? What's the problem with people using the phrase 'sorry not sorry'? Or with announcing the sports successes of their children by writing 'proud of this one', with commenting 'well jel' under the photo of 'heaven on earth'? Is the sentence 'sitting down to dine with our nearest and dearest' really enough to give up on someone?

Jane Austen's novel is a record of linguistic allergy, of a festering caused by certain sentences, phrases and mannerisms.

Chapter nineteen. Emma visits Miss Bates and her mother in a modest house where the two women 'occupied . . . the very moderate-sized apartment'. What we learn about the older lady is that she is neat. The younger – energetic and talkative – explodes into a monologue that takes up four subsequent

pages. Boring, chaotic, dense with repetitions, larded with courtesies, obsequious and boastful, marked with ellipses, pinched with brackets, full of various 'often says' and 'I do not know that I ever saw anybody more surprised'.

This logorrhoea contains mainly praise for her niece, one Jane Fairfax, and a detailed report concerning her activities and plans. After page two, we're already sick of this character. We burn with deep, intense dislike towards her. The tortured Emma listens (her 'politeness . . . at hand directly') and suddenly 'an ingenious and animating suspicion' penetrates her mind. It's about 'Jane Fairfax [and] this charming Mr Dixon'.

Clearly Emma is counting on Jane having an affair with her married protector. The hope that the humble young woman has strayed from the path of virtue will stay with Emma for the next two hundred pages. 'This amiable, upright, perfect Jane Fairfax was apparently cherishing very reprehensible feelings' – she will rejoice in chapter twenty-eight.

The main character might be driven by ambition, selfishness, jealousy, but why on earth would the reader share those feelings?

Suddenly, Ms Austen pivots. The beginning of chapter twenty is devoted to Jane Fairfax, who has still not entered the stage. The narrator starts with the words 'Jane Fairfax was an orphan', and then offers us the sad and compassion-stirring story of this – hard to disagree – 'sweet, interesting creature'.

It's a game. Reader, do you still feel solidarity with Emma? Do you continue to share her dislike for the 'quiet neat old lady', Mrs Bates? Do you still have the urge to take a swing at her kind little head? And the decent orphan whose fate has tried her sorely, the apple of her auntie's eye, how has she wronged you?

So what's it going to be? You can save Emma from damnation. You can show solidarity in antipathy or distance yourself with a shrug. You can ask: 'What's your problem, Emma? They're such good people.'

Well done. Go ahead. Push Emma away with a boat-hook and drown her in tar. What Austen has done is perform a classic motherly gambit. She provoked us: she presented a verbatim record of Miss Bates's words, presented it so maliciously that she would only be equalled by journalists transcribing a recording of a politician's locker room talk.

She kept every inanity and every platitude, she made us see every single word making up this gibberish, until we were convinced. Now she looks at us innocently and accuses us of pettiness. Oh, it's as if I was listening to you, mother dear:

'I honestly don't get what you're talking about: he's such a nice man!'

'You should be ashamed of saying such things.'

'They're only human.'

'You nasty boy.'

My mother could hold a grudge. She carefully measured out understanding. But she was also able to find new reserves of tolerance and gentleness when she wanted to annoy someone.

—

In the book, Emma is taken to task. To this end, Austen sends in the sanctimonious Mr Knightley, a pompous bore who brings another portion of admonishment every few chapters. 'For shame, Emma!' And indeed: she suffers pangs, pricks, jabs, blows of conscience. It's not nice to make fun of old ladies. It's rude to sneer at orphans. For shame!

At the end of the book Emma gets unbounced like *Winnie-the-Pooh*'s Tigger. She becomes – at least temporarily – a docile, repentant, grateful Emma ('How nice to see you, Pooh').

Fortunately, there's also Mrs Elton, a character – as my mother once explained to me – created to be disliked. The narrow-minded, pushy Mrs Elton forces her way onto the pages of the novel only to irritate. A repulsive parvenu unprotected by emotional blackmail. An allergen. Hazel pollen, red eyes, swollen throat.

Thanks to Mrs Elton, stubbornly mincing along the fore-ground, huge like a swollen finger or a sore tooth poked by the tongue, thanks to that harridan in whose character we recognise features of so many basically harmless people . . . It is thanks to her that the true, unyielding, monumental shrew-ishness of Jane Austen emerges.

Mrs Elton. The current of her speech carries all the most irritating phrases, mannerisms and boasts. The tales about her brother-in-law's carriages. The epithet 'lord and master'

which she bestows upon her husband. That '*caro sposo*'; the
clichés repeated for maximum effect, 'Surrey is the garden of
England'. Argh!

Even the narrator emits dislike towards Mrs Elton. They
make do with laconic remarks, but our own shrewishness
immediately deciphers the signals. Mrs Elton is 'as elegant
as lace and pearls could make her'. On another occasion she
is 'all . . . warmth, energy, and triumph'. Finally, it's enough
to remark that she appeared in a 'large bonnet'. That's all the
fuel aversion needs.

Certainly, Emma's little jokes have an edge of class superiority.
Disdain for the parvenu who flaunts her position. A reminder:
you will never become one of us. Your efforts are too frantic,
too ostentatious. Your impudence is tinged with desperation.
And struggle.

No, it's no use. It's impossible to feel sorry for Mrs Elton.

'Is she not very charming?'
'Oh! Yes – very – a very pleasing young woman.'

In the 1961 edition there are illustrations at the end of each
chapter. Figures the size of beetles. Pointy slippers peek out
from underneath gowns. Legs shaped like clock hands indi-
cate the hour (twenty-five past five).

Emma is superficial, but water insects run across
that surface, their weight supported by the tension of the

conversation. Always on the move, they slide along the thin membrane. Their thread-thin limbs flicker. They're alert, nimble and cruel, like the great diving beetle. Even the sanctimonious Mr Knightley observes that 'disingenuousness and double dealing seemed to meet him at every turn'.

Amid that babble, the clearest sign that somebody has been hit is silence. A performed lack of preoccupation. Theatrical indifference.

Emma's eyes pursue her rival, but it's no good. Every time she gazes towards her, Miss Fairfax is engrossed in conversation. Or she lingers behind a little, 'too busy with her shawl'.

Something had to result from that. From the teeth-gnashing over Mrs Elton. The scoffing at the slowcoach hypochondriac Mr Woodhouse. From the obviously unfair dislike of Jane Fairfax. From those kilograms of apples eaten and the hundreds of Emma-hours that my mother clocked up.

Firstly: verbal agility helps in difficult situations. One must be a shrew. One must get friendly with words.

Secondly . . . I imagine my mother as she begins reading for the hundredth time. She can be sure that nobody will die in childbirth or be finished off by TB. Even the hypochondriac Woodhouse will make it to the last page. Old Mrs Bates will again gobble ham, tasty as always.

They'll remain in place with their flaws, selfishness, haughtiness. With their funny pretensions: oafish father, passive friend, irritating neighbours.

No two ways about it. We won't be given another set of people. You've got to live with them.

Thirdly . . . I don't know what the third thing was. It had something to do with silence. After my father's death and later, when she was ill, she never reached for that book. This time *Emma* was too feeble. Too weak. Below par.

Jane Austen failed her. Words failed her. I also failed her, but that was to be expected.

The most important shelf

Emma wasn't alone. Here is the shelf with my mother's favourite books.

From the left:

– Magda Szabó, *Old-Fashioned Story*. No dust jacket. Tattered cloth binding embossed with a small shape (which – I understood years later – represented the Hungarian flag). Damaged spine. Dust jacket lost.

– E. M. Forster, *Mrs Wilcox's House*. Cloth spine, cardboard cover with an elegant pattern. Design by Andrzej Heidrich. Title on a band. Band lost. Later the novel was reissued under a title closer to the original *Howards End*.

– John Galsworthy, *The Forsyte Saga*. No dust jacket.

– Vita Sackville-West, *All Passion Spent*. Black dust jacket with a white rose.

– Émile Zola, *Ladies' Delight*. Damaged paperback with a blurry painting by some Impressionist.

– Barbara Trapido, *Brother of the More Famous Jack*. Gaudy nineties cover. Design borrowed rather ruthlessly from Faber and Faber.

– Michael Cunningham, *The Hours*, hardback. Stills from the film on the cover. Time has stopped on *The Hours*.

Someone has probably already invented this: therapeutic literary packages. Seven titles for depression, in our autumn sale.

Ulitskaya

There was one other book, not on the list above. She read it only once. Time ran out before she could do it again. A thick novel by Lyudmila Ulitskaya. A saga about schoolmates, members of Russian intelligentsia. Dissidents, half-dissidents, quarter-dissidents and friends of dissidents.

The novel begins – of course – in Moscow in March 1953. The radio has just aired news of Stalin's death.

The plot takes place over the next forty years. As tends to happen in novels with many characters, threads unravel, single strands break off in various places and times, and disappear from sight. Life follows its own path and course, oblivious to the gaps.

'It's like I'm reading about us,' my mother said. 'There are so many things that only our generation would understand.'

'Seriously?' I was surprised. 'You've never even been to Russia.'

'That doesn't matter.'

Maybe not. She lived in the same empire. She also learned from the radio that the heart of the 'comrade-in-arms' and 'genius continuator' had stopped beating. And a bit later, that summer, when they were in the mountains, she listened to the planes flying towards Czechoslovakia during the night.

She knew the same songs too. The same films. She was moved by the one about flying cranes (she got over it in time). She even worried a little about the fate of the Crimean Tatars and General Petro Grigorenko.

The local specifics don't really matter. National differences are not worth exaggerating. She wanted to see a novel like this about her generation. About her acquaintances and friends.

This book would start in Klement Gottwald secondary school, or a charity-run primary school or even earlier, in kindergarten. Or under the supervision of a grumbling, dour childminder, because they were brought up by nannies and childminders. Later the time would come for summer holidays, scout camps, songs, romance, the obligatory farewell scene at Warszawa Gdańska train station. There would be countless flashbacks, family secrets, accusations. Plenty of secondary characters, places, the kinds of details I'd heard throughout my youth.

'His father was Warsaw's best abortionist.'

'They told him he needs to do well at school because his daddy works for the Ministry of Education.'

'She was a lesbian and that really worried our mothers.'

And:

'Once, in front of us, her mother opened a wardrobe full of jumpers, those colourful imported jumpers, and asked: "Why did she do it then?"'

No book. No such luck. All the descriptions, digressions, props and gossip will go to waste. Anyway, I doubt something like that would have been readable. It would have added up to a tacky roman-à-clef. An epic denunciation or just another encyclopaedia of the smugness particular to her generation.

After my mother's death an acquaintance of hers showed me a photo album.

'It contains many photos of Joasia,' she said.

I turned the pages with a polite expression on my face. I couldn't find her. My mother didn't like to be photographed. Her unerring intuition always directed her to a spot to the side, half a step beyond the frame. With her back to the camera. As a last resort, she would find someone who, as the shutter released, would stand up straighter, shrug their shoulders, wave – and obscure her forever.

At least she got to read the Ulitskaya.

The Stalin cookbook

My mother's parents spent the war in Russia. Grandma had a cookbook from there. During an apartment renovation drops of white paint had fallen on its brown cover, which made it look even more like damaged furniture.

A strange book, with a quote from the leader on the frontispiece, and colour photographs. The illustrations were riveting. Grimms' fairy tales for future generations.

Ripe fruit and vegetables. Tinned peas. Cold cuts. Chickens. Suckling pigs. Trembling flowers made of mayonnaise. Tins of fish (on the label a cutter fights a wave in the background; all hail the sailors of the fishing fleet).

Charcuterie marbles, frankfurter colonnades, grape bas-reliefs: the Moscow Metro of comestibles.

The alcohol bottles were the most beautiful. Their labels were painted in on blurry photos. Later, I encountered the names again in Yerofeyev's prose poem *Moscow Stations*. The heart bleeds when Venichka begs to be sold some sherry.

> 'What about sherry?'
> 'We've got no sherry.'
> 'That's funny. You've got cow's udder, but no sherry?'
> 'Extre-e-emely funny, that's right. Udder yes, sherry no.'*

Poor Odysseus among the products of the Soviet distilling industry.

A crazy book from a country where grandma starved. She didn't talk about it much. Only that they went voluntarily. That it was cold: spit froze before it reached the ground. And that the Russian word for 'forget' sounds like the Polish for 'remember'.

A memory of hunger and Rubenesque still lifes. A memory of frost and vanilla ice cream.

The USSR arose from famine. It starved its own provinces and cities. The famine was always changing. It intensified. It abated. Receded and returned. It became a shortage. A temporary non-availability, a delivery disruption.

* Translated by Stephen Mulrine (translator's note).

Famine remained close by. A retired monster. An old tormentor, a recollection of a bygone era. Like Marshal Semyon Budyonny at a Komsomol congress. (A photo, the seventies: Komandarm moustache and party activist sideburns. Uniform and nylon shirts all around.)

* * *

The cookery book is an erratum. A simple corrective. You must believe in all of these illustrations. Eat the pictures. Ignore the evidence presented by your other senses. *The Book of Tasty and Healthy Food* is a basic lesson of communism. No one ever cooked from it.

Andrei Khrzhanovsky's film was entitled *A Room and a Half*. *The Book of Tasty and Healthy Food* had a bit part in it. An animated Stalin came to life and spoke to little Joseph Brodsky from the photographs:

'You are a Jew, boy, and Jews only eat matzo. I have no matzo. But I have a good idea for Jews. Do you like to travel? I'll take care of you. You'll have plenty of matzo in Birobidzhan.'

During a screening in Warsaw I approached the director.

'My grandma had that book too,' I stammered, summoning the last remnants of my Russian.

'Everyone had it,' he shrugged.

Sugar

There's a cardboard box in the depths of a drawer. The letters are barely visible, but you can make out the inscription: 'To Joasia, for a sweet life', and the date. It's American sugar, UNRRA aid. In 1946 people gave each other gifts like this.

She never opened the packet. All these years later, the sides gape. Crystals of sugar scrape along the bottom of the drawer. I lick my finger. The sugar tastes ordinary.

Canada

A ragged English textbook.

> The egg is in the egg cup.
> The boy is in the bed.
> The girl is in the classroom.
> The aeroplane is in the sky.
> Where is the egg?
> Where is the boy?
> Where is the girl?
> Where is the aeroplane?

And lower down, in pencil, a barely visible note:

> Read: erplein.

In the 1980s my mother began to say she wanted to leave for Canada. She never applied at the embassy, never filled in any

forms. She was just saying it. It was her universal punchline. An answer to everything. The last bargaining chip.

'This is unbearable. Need to leave for Canada.'

Sometimes she elaborated on the topic.

'You'll go to a Canadian school, it won't be easy, but you'll manage,' she predicted. 'Your father will find work as a draughtsman, just at first, to show them what he can do, then they'll believe in him and everything will change.'

She didn't tell my father about these plans. He had no idea he'd have to prove himself to Canadian employers. The only thing my mother did to prepare was to enrol in an English course for adults. Her classes were in the afternoons.

'When the timer rings, turn off the heat. You'll remember?'

She looks through her notes. The notebook is dog-eared and scrawled all over. She's learning from a textbook for young people.

'We had homework,' she says. 'Today I'll have to talk about what my dad does.'

'Your dad?' I repeat.

I've always been afraid of this. That one day there will be a question without an answer. A question about something we've not covered yet. About negative numbers. Or the Centrolew.

'But he's dead. What will you say?'

'That he's dead.'

'How do you say that in English?'

'I'll think of something.'

But it seemed she couldn't, because soon after that she stopped learning English. A few years later she went on a diet. Then the political system changed. For a few years she was happy. Happier.

Weather forecast

I find a scrawny stack. In the sixties, publishers weren't yet shy about releasing small books. They printed thin volumes without padding out the margins, font size or leading.

The screenplay for Antoni Krauze's film *Weather Forecast* was also based on a short story by Marek Nowakowski. It takes place during the coldest winter of the century. The residents of a care home find out that the manager has purchased a larger than usual number of coffins. They panic and organise a collective breakout, pursued by firefighters. This last detail was the result of long negotiations with the censors: the authorities wouldn't agree to the police or the army.

My mother liked the film. A few days later she summarised it to her mother-in-law: 'The elderly people come to the conclusion that the manager wants to do them in.'

The worst part about it in my grandma's eyes was that she'd gone to the cinema with some friends who were visiting from abroad ('Rudi didn't understand a thing, I had to explain'). Grandma always insisted that one shouldn't complain in the presence of people from 'out there'. Because in every country dogs bite, but it's an ill bird that fouls its own nest. And they might think we want something from them.

'And after the film I said,' my mother continued, 'look, this is exactly what the welfare state is. Like it or not, it'll care for your welfare until you kick the bucket.'

She didn't even say 'kick the *bloody* bucket', but passive aggression hung in the air anyway, like a battleaxe.

Criticising the social achievements of socialism and Nowakowski on top of that?! Ah, such a talented writer after all – grandma had been his publisher and liked him – but now? He wrote for the underground magazine *Zapis*. In samizdat. In Paris. Such a shame.

Grandma was of the opinion that political engagement was always followed by a decline of artistic merit. Objectively and impartially, she didn't like the books of opposition writers. They got sidetracked. They went astray. As if to spite her, they wasted their talent.

In the meantime, my mother was elaborating upon an immensely amusing scene in which the elderly people lit a fire and sang the folk song 'The Red Sash'.

'Oh yes,' said grandma, 'those are all the songs of our youth.'

My mother could strike so many subtle blows. But this time she had encountered a more powerful opponent. And

all it had taken was the elegiac 'Those are all the songs of our youth'.

Ding, ding. Enough said. The match was over. In the car on the way home my father hissed:

'It takes exceptional tact to talk about that film to a seventy-year-old woman, especially when you insist on using "elderly" in every sentence.'

'Your parents are in no way elderly,' replied my mother.

They said no more after that. It was raining. The neon sign was glowing on the front of the Moskwa cinema, because it had not yet been demolished.

Many years later the taciturn Nowakowski, that expert in short sentences and thin books, became a favourite and a patron of the right. Funnily enough, his followers loved to pile up the adjectives. Contemporary books are also becoming ever thicker and more lightweight. Mainly thanks to paper bulking technology.

Clippings

'Our mothers didn't teach us how to cook,' she'd say. 'We were raised by housekeepers.'

She also claimed – having switched to the singular – that her mother's housekeeper had secretly baptised her 'by water' (whatever that means). That brave woman saved my mother's soul. But she didn't teach her how to cook either.

'Our mothers were building communism,' she'd add.

As if! My mother's mother was a relatively harmless builder of communism. She didn't lose her common sense. That is – she kept her pessimism. She worked on the margins, busy with publishing children's books, and around 1968 they whisked her away to retirement.[*]

[*] March 1968 saw student protests and the culmination of an anti-Semitic smear campaign in Poland. Many Polish Jews were fired from their jobs and/or forced to emigrate (translator's note).

She didn't teach my mother how to cook. Maybe she didn't like it. Maybe she couldn't be bothered. Maybe food wasn't important. Maybe nothing was important. Maybe she didn't have the strength.

Once she had been whisked away to retirement, she would fix things up for herself without much conviction or interest. Sometimes she pickled cucumbers, fried sweet angel wings. From time to time she made jellied carp.

It's possible that it was about something else. It's possible that it was about the usual: blurred memories of family homes. Recipes that nobody wrote down in time. Dishes which were renounced.

Only desserts somehow survived on Aryan papers. Cheesecakes and poppy-seed cakes, which I later recognised in the photos in some golden guide to Jewish cuisine.

And carp in muddy aspic. Licenced representative of an extinct tradition. Sad blind creature crushed by slices of carrot. Why carp in particular? Was there nothing better?

Mother had a favourite aunt, about whom she would tell various stories.

During the occupation the aunt went to have her Easter food blessed. She had a wonderful counterfeit basket with a lamb made of sugar and a ring of sausage in it. A first-rate basket, better than a baptism certificate. And suddenly, on the stairs, she was targeted by a neighbour's vigilant gaze.

'What's this? Sliced eggs?'

'Mummy always had them sliced!' Aunt kept a cool head, and her life.

So my mother filled in the gaps step by step. She learned everything. Apart from frying angel wings and making jellied carp.

Because she had no oral tradition at her disposal, she believed in the printed word. She amassed a library of cookbooks (of which she rated only a few). She kept black binders full of clippings. Albums with pages from old newspapers. An archive of paper scraps and notebooks.

She would squander olive oil, clarify butter, purée tomatoes, add garlic to salad. She bought rock salt from Kłodawa, and attacked rice with yellow curry powder – long before the first follower of the Hare Krishna appeared in town.

Everywhere else – in schools, nurseries, workplaces, canteens, and cafeterias – they served white, squelchy gloop. My mother's rice was intensely yellow. Almost orange. It glowed like a fog lamp.

Portly dumplings in regional dress jump around on the cover of the cookery book.

My parents' first winter festivities together, six months after the wedding. It was a rather patriarchal gift. Writing smaller than the hand I was used to – rounded and modest. It was only later that my father's handwriting turned impetuous and impatient.

TO JOASIA CHRISTMAS 1969

My father wasn't particularly effusive, but he could draw the outline of a star with five perfect arms. He traced the shape with a steady hand and ended at precisely the right spot.

I know, now I know. You don't say Christmas. Later I discovered the existence of Catholics. They owned the copyright for that festival. Apparently, our Christmas celebrations had been totally illicit.

Thankfully we had them: a pair of cookery guardians. A foster family. Our guides were wise, tolerant, sceptical, reserved and loyal.

Their real names weren't known. In the old *Przekrój* magazine they wrote for this would have been normal. That whimsical Kraków weekly was teeming with mysterious authors and split personalities. But the fashion for those plays on words was over.

In *Ty i Ja* monthly, where they also published their recipes, the mood was no-nonsense. Authors featured under their own names. They were alive and tangible, they walked around Warsaw. With one exception.

It was difficult to believe that Maria Lemnis and Henryk Vitry really existed. Especially considering that the encyclopaedia

identified Philippe de Vitry as a fourteenth century composer and a music theoretician.

My mother claimed that behind the marital pseudonym were two guys. I believed her, and it added another meaning to their love story, described in the foreword to their first book, from 1959:

> We started with scrambled eggs and potatoes. When we met, I could already prepare delicious salads, and Henryk excellent beef steaks. Soon we got engaged. Together we prepared a 'cold buffet' for our wedding (we share the recipe with you in the chapter entitled 'Guests').

Purple background. A frame in the shape of an egg tied with a ribbon. Paragraphs separated by small drawings of hens. Later the culinary centrefold from *Ty i Ja* was shown as one of the outstanding achievements of design. My mother unscrupulously tore it out of her copy of the magazine.

Now the paper is brown, covered with a pattern of small spots and stains. The edges are frayed. The text is illegible on the folds. And she drew a little illustration on it too.

This scrap was part of her dowry. A dowry she cut out herself. These scraps were our home's constitution, a declaration of independence and a foundation act.

Mother was always afraid that the *Ty i Ja* recipes would get destroyed. She used all possible methods of reproduction to save them. She made greyscale photocopies when photocopiers first appeared. She made colour copies when colour

Minolta copiers reached Warsaw. She made scans as soon as she bought herself a scanner.

Maria Lemnis and Henryk Vitry. Their jokes were preceded by an old-fashioned ellipsis. Just imagine, sir, here comes . . . the punchline. The forewarned reader stops to smile, the plot rattles on. They would emphasise the most important words with spaced out letters. They signalled a metaphor with inverted commas.

The recipes were humble, inventive and straightforward like the sixties. Czech cabbage pie. Swedish apple pie. Swiss casserole with Emmental cheese. I still don't know if the place names described the origin of the dishes or expressed a longing for Europe.

In 1974 *Ty i Ja* stopped appearing in print. The authorities stemmed the flow of clippings.

My mother bought *Polish Cuisine* instead. A dour volume in grey cloth. The illustrations resembled those in a surgical textbook.

Later, in the eighties, their book *Old Polish Traditions in the Kitchen and at the Table* came out. The publisher, Agencja Interpress, managed to misprint one of the authors' name. To cover up their mistake, they stuck a patch with correct spelling over the error. Father immediately detached it – the name printed underneath was 'Maria Demnis'.

The book contained lots of text in italicised Garamond as well as old sepia prints. The contents featured the following recipes:

- Beef tongue in grey sauce
- Whole roasted pig
- Saddle of mutton in cream
- Saddle of wild boar in hawthorn sauce
- Roasted partridges and quails
- Polish-style hare in cream

When she got to the recipe for 'hare in cream' it became clear that the paths of the Vitrys and my mother had definitively parted.

But they were to meet again. In the last binder I find the epilogue. Jolanta Kwaśniewska's presidency was just around the corner when the mysterious couple returned. Now they had a byline in *Twój Styl* magazine.

No chickens jump around on the clipped pages. No longer do huge apples tumble about; there are no colourful eggs inspired by Fangor's paintings. Illustrations had been supplanted by colour photographs of the dishes. 'This pike in champagne will dazzle your guests' proclaims the caption.

The paper is white and glossy. The advertisers must have adored it. Printing techniques had replaced imagination but, on the other hand, shops had started to sell gorgonzola.

Gorgonzola

Between the pages I find one last piece of paper with new ingredients and new possibilities jotted down by my mother, ever the diligent student:

- lasagne
- mozzarella cheese
- fennel
- fennel with gorgonzola in the oven
- pears with grana cheese
- ~~pecarino~~, peccorino (cheese), grate over pasta with pepper.

Rainbow vacuum cleaner

For years she wanted to purchase the very special Rainbow vacuum cleaner.

It cost a fortune. They didn't sell it in shops. The vacuum cleaner had its believers who went around people's homes like Jehovah's Witnesses.

Middle-aged ladies, former clerks or teachers, abandoned their previous jobs. They followed their faith. They preached the vacuum cleaner. The most famous hymn of those years – John Paul II's favourite song – praised occupational mobility, in fact.

> Your lips have called my name today.
> I'm leaving my barge on the shore,
> And today I'll start a new catch with You.
> O Lord, with your eyes you have searched me,
> And while smiling have spoken my name;

Now my boat's left on the seashore behind me;
By your side I will seek other seas.[*]

Former employees of state institutions searched their address books, chose potential clients – picked a friend of a friend – and cast their nets.

Presentation day arrived. The selected hostess made tea and passed around biscuits. The ladies looked at graphs. They listened to readings from the branded ring binder. Then the time came for practical exercises. You pour the water in here. No, it doesn't need to be distilled, you only have to boil it. Take a look, it's completely clean. Power button here. Any questions? Biscuit, anyone?

Finally, the committee poured away the used water, dirty like melted snow. But the house had been cleaned so thoroughly before the guests came! ('to terrify me i.e. to convince me'[†] – reminded the poet).

My mother really wanted to get rid of the dust breeding in the books and spreading under the furniture.

Maybe she didn't like the sparkling motes that whirled in the air, attracting allergies, diseases and bad memories. Not for her, stars and planets revolving in space. Chaos was waiting to engulf us. Chaos. Helplessness. The rebellion of objects. The rebellion of cells.

[*] 'Lord, You Have Come to the Lakeshore' by Cesáreo Gabaráin, translated by Gertrude C. Suppe, George Lockwood and Raquel Gutiérrez-Achon (translator's note).

[†] Zbigniew Herbert, 'Parable of the Russian Émigrés', translated by Czesław Miłosz and Peter Dale Scott (translator's note).

Dreaming of things takes us back to childhood. Unobtainable objects let us give form to sadness. Describe what we miss.

We definitely would have been happy if only my mother had bought the black, barrel-shaped vacuum cleaner which could suck dust out from the air forever. But it was too expensive.

While sorting out the flat I find an old advertising brochure for it, full of charts and photomicrographs (look what lives on your carpet). A mite grins triumphantly.

Electric train

In every Empik bookshop there's a shelf with books marketed as the Polish *Le Petit Nicolas*. In the Polish equivalents of that French children's classic, the cheerful scamp begins to look like a plastic puppet. He grows, puffs up and his smoothed-out silhouette fills the pages, while the scenery has been reduced to a minimum, a few splashes of colour in the background.

Jean-Jacques Sempé's original illustrations had it the other way around. Somewhere near the bottom of the page small figures roamed – boys walloping each other with their school bags – and above them rose walls, towering tenements, plane trees, the whole city outlined down to the last leaf, gutter, cast-iron balustrade and topmost garret. Paris going about its business. A merry version of *The Fall of Icarus*.

Nicolas was a child of the post-war years. His parents bought the first television set, the first car, and then – benefiting

from paid time off – went on holidays, only to immediately get stuck in a traffic jam. Traffic jams were new too.

René Goscinny, the author of the book, was from our parts. A Jew with a paunch. On a swanky snow-white type-writer he clattered off stories and scripts for comics. I hope he had fun doing it.

Have fun. Be happy. Cheer up already – this is what the post-war world asked of Nicolas.

Mr Goscinny was eventually killed by an unhealthy lifestyle. He died of a heart attack or stroke during a stress test at his doctor's office, on a stationary bicycle. Fat bloke pedalling with his knees under his chin. An image straight from a cartoon, from the chapter in which Nicolas's father races on a child's bike – and, of course, crashes into a rubbish bin (handkerchief, blood, smashed nose, smashed glasses, broken wheel, spokes poking out in all directions). Fathers are perishable.

Poor Goscinny orphaned a daughter. Years later she wrote a book about her parents, short, not too good and very sad. And perhaps that was the sequel for *Le Petit Nicolas*.

The only book which would have the right to stand on the shelf for Polish *Nicolases*, if only someone would reissue it, is called *Small Fry*. Written by Maria Zientarowa, it was *Nicolas avant la lettre*. It was first published in 1955, four years before the French counterpart. It's a collection of stories about a happy childhood in Stalinist times.

My mother wasn't particularly attached to this book. She wasn't keen on its tone, wasn't sentimental at all, especially when it came to her own childhood. She had no reason to be. She treated good memories like the newsreel in a documentary. A quick montage of scenes precedes a catastrophe. Look, here is life going on as normal. Cinemas show bad films. Sportspeople in funny outfits break records. Let's have a shot from a poodle show. The figures on the screen don't know what's about to happen, but the background music takes an ominous turn, drums roll and there's a fade-out. Behind my mother's happy memories there was the ticking of a clock.

She didn't have a nostalgic reaction to *Small Fry*. If she didn't throw out her copy – published in the eighties, in any case, with a ghastly glossy brown cover – it was only because she had a rule against throwing out books.

But I pardon this volume too. I take it aside. I put it on the 'to keep' pile because of one chapter, one scene. In it the parents take the boys to Warsaw's Central Department Store, or the former and future Jabłkowski Brothers Department Store.

> Inside there was a cosy semi-darkness, from which – once the eyes got used to it – emerged a wonderful, enormous electric train.

The story continues:

> 'Sometimes it actually runs,' said a girl with a black fringe. 'Maybe not today, because I've been standing here a long

time and it hasn't moved. But my big brother said that two years ago, on the holiday for the 22nd July, he saw it running with his own eyes.'

'It's January now,' said Janek's mother. 'Let's go and see what else we can find.'

'I'll wait here until it starts running,' said Andrzej very firmly. 'I don't care what else we find, because it's not my birthday anyway so I won't get anything. I'll wait here until they start the train.'

For a moment I feel like I'm there too, on the ground floor of the department store, among the clients' damp coats, looking at the mountain made of paper, the sponge trees, the railway tunnel fringed in a brick-red trim, the tiny semaphores.

My parents are in the crowd, a few years old, excited. They don't know each other yet. They have been asking to be brought here for ages. The grown-ups had been promising for weeks, but they never had the time, long hours, a meeting, a work trip, but at last, finally.

Any moment now, the electric locomotive will appear. It'll be here very soon. For certain. The children watch, jostle, peer from behind their sleeves. The electric train isn't coming, but don't lose hope – any moment now.

Too much

Two short stories make up the volume *Reality and Daydream*, a wafer-thin book, although bound in cloth. Słonimski wrote it in the sixties. I read this *Daydream* instead of packing. There's something off about the concept of returning to the old hunting ground, reaching for the punchlines of Jewish jokes, using gags from pre-war cabarets to tell the story of an old Jew in communist Warsaw.

Towards the end of the Polish People's Republic a TV adaptation of one of the short stories was made. It starred an actor who always played Jews in post-war films. All the rabbis, merchants, industrialists, doctors, lawyers, receptionists and Jewish tailors who appeared in Polish cinema always had the same voice and the same face. As a child I thought it was the only Jewish face allowed. All of its users had to share it, having agreed on a schedule.

It was the same face as the poet Julian Tuwim, author of the epic poem *Polish Flowers*. The actor inherited it from his uncle. When my parents caught a glimpse of the actor on the street or the screen – carrying his precious and fragile nose – they'd say: 'Tuwim's cousin' and 'like two peas in a pod'. At the time I was under the impression that it was a common term, a sort of euphemism. All Jews are Tuwim's cousins.

The film adaptation also featured the Messiah. They couldn't find a Jew of the right age, so the part was played by an Armenian.

In the story about the Messiah there's a key scene with the tailor, Rajzeman ('who is now called Dubieński and lives in Zgoda Street, which is now called Hibnera').

Rajzeman is ironing the trousers of doctor Walicki ('his name is Wajnsztajn, but he's always pretended to be Polish gentry'), and burns a huge hole into these trousers made from an imported fabric entrusted to him, the trousers of his last client. And then a miracle happens. The Messiah turns back time. The film runs backwards, the hole turns into a singe, then into a dark stain, a smudge, and finally disappears.

'And when I came back into the room,' recounts the tailor, 'the trousers were intact once more and everything as though untouched. I was still standing at the door when I heard a voice call out to me: ZEH HAYA YOTER MIDAI. Which means: It was too much.'

—

In fact, everyone wanted to believe that. That enough is enough, and lightning never strikes twice. That it's safest in the bomb crater. That the limit of misery and catastrophe had been reached – maybe not for ever, but for a long time. We didn't need to worry for a while.

With time we began to believe that we're running towards the future, like you run to your teacher with a complaint. And it would listen to us, scold the wrongdoers, force them to say sorry. And promise: never again.

But at school they taught us probability calculus. They said that the result of flipping a coin does not depend on previous results. Every time it's the same. Fifty/fifty. Sink or swim. It was only in my maths notebook that I saw life as a chain of independent events, a series of random repetitions, each of which proves: you are entitled to nothing. It scared me.

My parents and I went to see a historical film, something about the horrors of Stalinism.

'Could they do things like that today?' I asked after the screening.

'No,' said my father, reassuringly, and then he added, 'they'd think of something new.'

And then he giggled, because he wasn't the one in the family who usually did the frightening.

DICTIONARY

Mistress of ceremonies

We need to hire someone to lead the ceremony at the funeral home, to say in a well-trained voice: 'today we are saying goodbye', and 'now we will walk to the grave', so that everything runs smoothly.

'I'll show him to you online.' The manager clicks on her screen.

We stare at the Google search results. All the photos show funerals, white lilies and crowds of people. I'm trying to find the face that reoccurs.

'He's the one in the surplice. Very dignified leading.'

'All right then.'

'Only, just to warn you, we have had a slight issue with him. But you can't please everyone, can you.'

'An issue?'

'He doesn't look like this any more. Handsome boy, I really don't know why he did it.'

'Tattoo?'

'Hair.'

'Long?'

'Shoulder-length, but clean. He uses all these special conditioners, I must ask him what.'

'We'd rather someone else.'

'In that case may I suggest the mistress.'

'The master's mistress?'

'His wife. He writes the service, and they lead alternate ceremonies in turns.'

We agree. The manager leans in and asks her final question:

'What about the music? I know it's a secular ceremony, but would you be against "Ave Maria"?'

A few days later the master sends us a draft of the eulogy:

> We have gathered here today within these walls to say a heartfelt goodbye to Mrs Joanna, and to offer our support to her loved ones on this difficult day. Many lives were touched by her: to some she was a friend, a fond neighbour, colleague, an outstanding expert in her field. To her loved ones: the most beloved wife and mum, grandma, sister and aunt – an irreplaceable member of the family.

My mother checked my essays throughout school. She crossed out facile adjectives. Hunted down trite set phrases.

In the 'funeral ceremony programme' words walk in pairs, like students at a dance school: fond neighbour, outstanding expert, irreplaceable member.

For a moment I'm itching to accept it. I'm still furious with her. But there are limits. I'm supposed to allow a stranger to call my mother an 'irreplaceable member'? Or even a 'fond neighbour'? He might as well have added she always said hello on the stairs. These are the kinds of things people say on documentaries about serial killers.

I write my own version. Actually, I don't write it. I collect memories from friends (she always said friends were the most important thing in life); from family. From both adults and children. I go to pieces only once. At this email:

> She respected all her patients equally, regardless of their age. This also applied to pre-school children; she gave them a lot of attention and did her best to talk to them 'at their level'. She always kept her eyes at the level of the child's. When her back pain got worse and she could no longer bend down or sit on child-sized chairs she gave up working with kindergarten children, because it would have meant breaking that rule.

A few weeks pass. The flowers and candles have been cleared away from the grave when the mistress calls.

'I wanted to thank your mum,' she says. Even on the phone her voice is really good. 'I'd like to thank the doctor through you.'

'She wasn't a doctor,' I reply.

'While I didn't have the pleasure of meeting her person-ally – in my job that's normal, I'd think – she's still had an influence on my life. We had a funeral last week and there was a two-year-old boy there. He didn't really know what was going on. And then I recalled the doctor's words.'

'She wasn't—'

'That your eyes have to be at the level of the child's. I crouched down. I took his hand and crouched down. Everyone was surprised that the master of ceremonies had suddenly disappeared. And I let him throw soil on the lid of the coffin. We threw it together. Once he'd started, he didn't want to stop. So in a sense, I am the doctor's student.'

'She wasn't a doctor.'

Handwritten notes

My mother wrote with supposedly long-lasting ballpoint pens; my father used permanent ink. Absurd names, I think, while sorting out their papers. Nothing is permanent. Even lasting long is not a given.

My mother used up dozens of sheets of paper, note-books and agendas. She wrote assessments, notes excusing students. She was surrounded by phone numbers, shopping lists, recipes, amendments to recipes, practical comments and warnings formulated after recipe testing. And gasket sizes, where to get wool carded, names of medications, surgery opening hours.

My father didn't write much. Reviews of architectural designs. Memos about residential constructions which had to be typed up later. Sometimes a to-do list for Monday ('Mon'). Each point on the list was preceded by a dot or a tiny square.

My mother used BiC ballpoint pens, the yellow ones. Later also the Cristal model. She kept losing them, leaving them at work. Her pens lost their caps. Cracked. Disappeared without a trace. Later others would appear.

My father used fountain pens. Some he inherited from his father. He carried them in a leather case and obtained the ink at a shop on Chmielna Street. Sometimes they played tricks on him. A stain would spread at chest level. An alien shot in the heart (yes, he used green ink). My mother tried to wash it off. My father wiped the nibs with a handkerchief. Sometimes he left them overnight in a cup filled with water to soak them. When he finally got down to writing, his words had weight. They concerned substantial issues.

My mother drew flowers. Nervous ornaments around the surgery's phone number. One busy number – one flower. Most probably a gerbera.

Writing with a pen is like fencing or dance. The line's thickness changes depending on the inclination of the nib and the angle of attack. Thrust. Return (the nib pulls an arched trace behind it). Jump. Elegant retreat.

The ink dries. Or it smudges, drips. A fountain pen is alive. My father coped with it. He frolicked. He forced it to submit – like a circus trainer.

Sometimes he showed off. Drew bells with one perfectly handled arc after another. Small cars sprouting wing mirrors and antennae. Sometimes tanks, always with the hatch open and a reflector – a single searchlight aimed at the sky.

Once they were on a holiday in some guesthouse. Every morning boys gathered outside their room:

'Mister, draw us a tank.'

Nobody asked my mother to draw gerberas and misshapen children with round heads and masses of curls.

Ballpoint pens are docile. They go on writing regardless of pressure, location and weather. Whatever happens, they leave behind an oily, glistening thread. A snail track. They write until hell freezes over, as my mother used to say.

And then the collapse. An attempt at first aid. Maybe it'll get going. A few loops. A thready pulse returns for a moment. No. No good. Pronouncement of death. Rubbish bin.

I read online that the ballpoint pen was invented by a journalist from Budapest.

The guy needed a tool to make corrections on proofs. He didn't want to wander around the printing house with a fountain pen or pencil. He had no time to fight the elements, so he invented the ballpoint pen.

The inventor soon stopped being a Budapester journalist. He turned into a Jewish refugee. And then into an Argentinean entrepreneur.

The first ballpoint pens were used for correcting columns about the work of municipal services. Only later did the Royal Air Force purchase a large batch for their crews (in high

altitudes fountain pens turned out to be as impractical as they were in the printing house).

Later presidents and leaders would perform their farce of power with fountain pens: initial a peace treaty, or an alliance.

But before that the real job had been done by some bomber who used a ballpoint pen to write down the target's coordinates, and the number of bombs dropped on Budapest or Dresden.

My mother had no time for fountain pens. She had errands to run. Everything happened with too much haste. Too many things beyond her control. So many things to keep an eye on. Prescriptions. Phone calls. Recipes. She had too many things to take in hand to amuse herself with unruly ink on top of that.

Typewriter

On a day-to-day basis you made phone calls. To the building administration. To the energy provider. To the water supplier. The director. The manager. Sometimes even to the municipal duty technician, a mythical figure, a black spider with a hundred eyes staring at consoles and screens. But most frequently – simply to Kopściałko the engineer. Usually about water. That there isn't any. That it's leaking from the pipes. That it's cold or rusty. That there's a damp patch, a stain, mould. There's no heating again. You called so that the caretaker would turn off the mains. So that he'd turn on the mains. So that someone would find the caretaker, the dead drunk guardian of the keys to the mains.

Pipes ran underground. Sometimes they surfaced like veins. They penetrated buildings. Wrapped us in a network of capillaries. In the bathroom they had been covered over by a

piece of pale yellow plywood, so that you didn't keep hacking open the wall and bricking it up again. Just move the screen aside and you revealed the innards of our world. Shoddily arranged bricks, rust, a musty smell, a black expanse and the neighbours' voices.

All around us was a splashy end of the world. An apocalypse of limescale and rusted pipes. To us, the film *Alien* was a depiction of a plumbing failure: broken walls and the ostensible peace destroyed.

In his children's book *Cyryl, Where Are You?* Wiktor Woroszylski blamed entropy for problems with the water supply. Andrzej Kondratiuk also made a comedy on a similar topic, entitled *Hydro-puzzle*. Songs and skits were produced. The favourite comedic cameo of socialist cinema remained the soaped-up man – as he wanders around, wearing only a towel and blinded by shampoo, in search of a plumber (or the drunk caretaker with keys to the mains).

There was a metaphor to be found there. But my mother wasn't into that sort of thing. My mother believed in individual responsibility. The system leaked, dribbled and decayed, but from behind the communal catastrophe emerged a specific face. Namely, the mug of Kopścialko the engineer.

But Kopścialko was elusive. He roamed the field. Disappeared into appointments. Went to see his superiors to obtain instructions. Most often he just wouldn't pick up or, treacherously, would leave the phone off the hook.

Sometimes, after her third unsuccessful attempt, my mother entrusted me with dialling the number. I turned the dial again and again. Nothing happened. Busy. Again. Busy.

My mother objected to easy excuses. She uncompromisingly rejected each and every:

'I tried.'

'I did my best.'

'I wanted to, but couldn't.'

'Get through to him,' she said. 'I don't care how many times you tried. You're to get through. I didn't ask you to try, but to get through.'

Meanwhile Kopściałko, I'm sure of it, sipped coffee from a glass, spat out the grounds and grinned cynically.

So many years have passed, and I still see him. Every time I try to get through to a bank's customer service line or to the local surgery. The engineer hasn't changed at all, he's wearing the same suit and the same smile, while I'm twelfth in line. All our consultants are busy right now, please hang up or press the hash key for more options.

Finally, the situation reached a point that merited the written form and my mother composed a letter.

Drip, drip. Enough of this. Drip, drip. A letter about the lack of water. A screed regarding the prolonged maintenance break. A memorandum on the subject of piping.

My mother's handwriting consisted of overlapping round loops – words resembled elongated clouds. Like the dust left behind by Road Runner on his way to Albuquerque.

Which was why this time my father dragged out the dirty yellow Łucznik typewriter. My mother typed out her missive one letter at a time. She used a maliciously prolix style, detailed and sarcastic. Mistyped words were crossed out with furious x's: xxxxxx.

> A month after the due date Mr xxxxx Kopściałko was so kind as to . . . kindly let us know that xxxxx. During a telephone conversation. As he . . . as on the prearranged date . . . On the prearranged day I waited for three hrs . . . However . . . Notwithstanding xxxx. How surprised we were . . . xxx xxxxx.

'Why are you writing this,' I asked, 'Kopściałko knows we have no water.'

'Doesn't matter,' she replied.

'He remembers what he said on the phone, because you shouted at him.'

'Doesn't matter.'

'Then why?'

'So he gets scared.'

'Why would he get scared?'

'Because when he reads a letter like this, he'll think I might send it to a newspaper.'

I froze.

'You'd send the letter to a paper?'

At that time we read the daily, *Express Wieczorny*.

'It says the same thing as everyone else, but at least it's funnier,' mother would say.

98

They printed cartoons. Gwidon Miklaszewski drew the Mermaid of Warsaw, the city's symbol – a merry snub-nosed little lady (in the background the Mermaid's husband appeared, always with an expression of indulgent surprise on his face). The misogynistic drawing was only one column wide, but at least it was a column snatched away from plenum reports, accounts of agricultural sowing, campaigns against substandard work, dispatches about how successfully law enforcement bodies had enforced a ban on illegal printing.

Next to the column, red boxes held titbits from around the world, intriguing reports about Japanese robots that were getting better and better at handball, and about old men in the Caucasus beating all records of longevity, setting an example to younger comrades from the Kremlin.

Professor Fyodorov treated eyes. A farmer from China has just inscribed the whole Little Red Book onto a grain of rice, admittedly an exceptionally sizeable one. The photo was a grey stain, so it might as well have been depicting work in the autumn fields or wads of dollars found in the hideaway of a captured extremist.

Most importantly, the *Express* printed a serialised novel. A crime story by a foreign author or – one suspected a hoax – the work of a fellow countryman hiding behind a foreign pseudonym.

The plot was hugely complicated. It was about a hitman. The protagonist had a unique professional code: he never took the life of any of his previous employers. Many rich men ordered random assassinations simply to secure their own futures (still the best marketing model I've ever heard of).

In the eighties, my mother and I fantasised about hiring this thug – with what money? – and sending him to finish off Kopściałko the engineer. Personally, I was of the opinion that on the way back he could also pay a visit to the teachers' staffroom.

This was long before the VHS revolution, so our dark fantasies were mostly fed by books: 'the stout man kicked in the door and wiped him out with his sub-machine gun', or 'his body fell under a wall marked by holes left by bloodied bullets'.

Oh yes! As he fell, Kopściałko would inevitably drag with him the office potted plant and the football pennant, and his participation award from the power engineers' sports day would smash into a thousand pieces . . . But to kill an engineer with a communist newspaper?

'You'll really send it?' I asked, terrified. Despite everything, it would be an unforgivable form of collaboration and snitching. 'You wouldn't!'

'Of course not,' she said, 'but Kopściałko will think I might.'

'Then maybe retype it, without those x's?'

'So he can see me making an effort?'

Then I understood. This is our power. We can describe the leaking tap. The unreliability of plumbers. We'll write a composition, we're good at that.

We'll send it to the paper, and they'll print it in the 'Letters to the editor' column immediately. Who wouldn't print such a beautiful letter?

Ah, engineer Kopściałko. How ashamed you will be! The whole city will read it. Your wife will gulp back her tears. Your children will burn with shame.

The boss will grab the phone and surely fire you. He'll give you your marching orders. Then you'll remember you were supposed to send a team to Madalińskiego Street. So many times you've been asked, reminded – and now?

Now you'll come running. You'll writhe on the doormat. But it's too late. You'll get what you deserve. All because we know how to describe a thing perfectly.

The difficult art of making a scene at the post office

'I'd like to cancel my mother's TV and radio licence, due to her death.'

'Oh gosh.'

'Well, yes.'

'That's not what I meant, it's just if it's about a licence, you'd better try counter C. Take a number and my colleague will let you know.' Just then a glint appears in her eyes. An idea for a prank. 'Or better yet, go to the information point.'

To them I'm a trap. A rotten egg. You can plant me on the colleague at counter C (a tempting thought). But you can also – even better – fob me off onto that shirker who's been sitting at the information point since this morning doing nothing but

selling the current promos: envelopes, eco-friendly toiletries and an Alice Munro short story collection.*

'I'd like to cancel my mother's TV and radio licence,' I begin.

Clack, clack, scrape – the acrylic nails scratch at the keyboard.

'This lady didn't pay the licence fee.'

'What do you mean, didn't pay?'

'Not since 1996.'

'I've got the account history.'

'Let me see.'

But my advantage immediately melts away.

'Why did she only pay seventeen złoty?'

'I don't know.'

'Then who's to know?' she hisses. 'This isn't how much a licence costs.'

The Alice Munro book has a glossy cover. There's a black and white photo of a headless woman on it. Sunlight reflects off the gloss, and next to it there's a First Communion card and a paper chicken. It'd be funny to go home and say: 'Look, I bought a book by a Canadian Nobel Prize winner at the post office.'

'What is this account number even? And why in Bydgoszcz?'

'I don't know, but my mother paid your employer seventeen złoty every month,' I say haughtily.

* A few months later the Alice Munro was replaced by books on Polish 'cursed soldiers'.

'Maybe she was paying off a loan?'

'She wasn't.'

'And how do you know?'

I try to imagine mother secretly taking out and then paying off a loan through a post office in Bydgoszcz.

I can hear the rustle of the queue. A few people want to buy overdue Easter cards or pay their bills. They're getting impatient.

I raise my eyes at the post office employee.

'Please don't use that tone with me,' I say.

This is the key moment. The moment the poet Cavafy wrote about:

> For some people the day comes
> when they have to declare the great Yes
> or the great No.[*]

The clerk must rethink her strategy, because until now her 'No' was only a small 'No'. A normal, routine 'No'. A 'No' that hopes it might just work. That I'll get discouraged and disappear, along with the death certificate and the account history.

The first 'No' is paracetamol. Tea with raspberry syrup. The hope it will nip it in the bud. That it will blow over, go away on its own. A rash nod, a hum of approval, a small movement of the eyelids might be taken for confirmation, acceptance, an

[*] 'Che Fece . . . Il Gran Rifiuto', translated by Edmund Keeley (translator's note).

obligation signed with a blue BiC. Electronic signature with a round stamp. And then that's it.

'Please don't use that tone with me.' I puff out my dewlap and ruffle my feathers.

Like in a dance, rhythmically and harmoniously, we approach the point called: 'I'm Not Shouting At You'.

'Please don't shout at me.'

'I'm not shouting at you.'

'Yes, you are.'

'You are shouting. Go ahead and shout at your wife at home, but not at the post office.'

'He's shouting,' confirms the choir of customers. 'And people are in a hurry.'

'She's the one shouting,' claims the choir of customers with tickets for another counter.

It's still all to play for. We're on the crossroads. One way leads to: I'd like to talk to your supervisor – you're very welcome – I'll write a complaint letter – write away – indeed I will – and a desperate attempt at slamming the door.

But we can still walk the path of de-escalation.

'I'm talking normally, you must've misheard,' says the clerk in conciliation.

'Certainly,' I admit. 'So how about that licence fee?'

Grate, clack, scrape scrape – the scratching of the acrylic nails is almost friendly.

'Maybe it's just for the radio?'

The tension recedes. Ships change course. Planes return to base. The queue sighs.

—

Entire states rise and fall. Sacred ownership rights change hands. Politicians face the State Tribunal or the International Court of Justice in The Hague. Only clerks are eternal. More powerful than prime ministers, presidents and secretaries. Because their superpower is indifference.

They can take a liking to you or bristle with hostility. But that's just appearances: they embody evolution. We are left behind, a species doomed to extinction. A fat flightless bird. A lumbering representative of megafauna and the primordial forest.

The caterpillar

The betrothed pair form a heartfelt mutual defence league, each of the partners supporting the other most loyally . . . Constantly in an attitude of maximum self-display, and hardly ever separated by more than a yard, the two make their way through life.

– Konrad Lorenz[*]

A good argument takes practice. A good argument takes caution.

No shouting. No using arguments which will be turned against us. No hurling of threats which we can't carry out. Play your cards right, even if you have a weak hand.

[*] *King Solomon's Ring*, translated by Marjorie Kerr Wilson (translator's note).

My mother practised at the post office. In the office. At school. At the housing association. She practised on shop assistants. Clerks. Receptionists. Teachers. Officials.

Rows were a kind of training. An interminably extended war game. She tested reaction times; tried out tactics.

Reconnaissance by combat.

I remember her on the seventh day of martial law:

'I'd like to know where my brother is. He was taken from his home by three civilians.'

'What's the name?' And a moment later: 'There's nobody here with that name.'

'In that case, I'd like to report the kidnapping of my brother by three men passing themselves off as functionaries of the Security Service.'

'Let me check again. What did you say the name was?'

Many months later, after one of the amnesties, I heard a certain opposition activist tell my father: 'With a wife like that you've got nothing to be afraid of.' No word of a lie. That's what he said.

They kicked up the best rows when they were together. My mother – emotional, committed, on the verge of hysteria. My father – distant. Together they attained mastery. My mother in attack. My father at the rear, seemingly uninvolved in the scene playing out, ready to step in and assist, imitating a second, pseudo-impartial opinion.

They were not troublemakers. They weren't argumentative. They walked the world like a couple of rakish jackdaws. Not ones to pick fights, just slightly bristly.

I can't do that. At first I delay, cringing with a fake smile, then I explode. My rows start too late and go too far. I have to apologise. Mollify. Withdraw in embarrassment, mumbling something on the way out.

And I started so well, too, in duet with my mother. I had my greatest success in early childhood.

'This counter's closed,' said the clerk.

'What do you mean, closed?' said my mother.

'Just closed.'

'Then why are you sitting here?'

'For decoration!'

And then my moment came. From somewhere near the floor, I delivered my line:

'Not much of a decoration.'

My mother was overjoyed. Still, she didn't expect much success in my future.

'You'll lose your teeth in the end,' she warned.

My father, a great devotee of crawling insects, myriapods, and earthworms, once showed me a furry caterpillar.

'She's saying to the birds: think twice before you eat me,' he explained.

The caterpillar had no stinger or shell. It didn't puff up like a toad. It didn't spread its wings. It made do with a humble warning: 'Eat me and I'll tickle your throat.'

That's exactly it. Be a rakish caterpillar. A cheerful, confident caterpillar. Don't step out of character. Don't get your hackles up. Don't feel sorry for yourself.

'You'd better leave me alone. Don't try anything with me, or I'll stick in your throat. Wheeze, wheeze!'

As if

One summer in the charming town of Kazimierz a horse-riding instructor appeared. He set up shop next to the flood bank.

For sixty minutes the apathetic horse circled on a lead. For sixty laps some jammy sod swayed on the horse's back, while the queue of future clients looked on tensely and glanced at their watches.

My mother let herself be persuaded. I climbed up and understood that horse riding is a fight for your life. Meanwhile, on the other end of the tether, the owner praised my extraordinary talent.

No pottery, fencing or tennis teacher has yet been born who hadn't tried this gimmick. The kid only has to nudge the keys, and the keyboard instructor strikes the pose of Wojciech Żywny, Chopin's piano teacher. 'Little Fryderyk is a natural,' he says.

The horse plodded on, I desperately tried to retain balance, the owner did his spiel.

'Such ease,' he smacked his lips. 'Posture like that on the first lesson! A born rider.' Later, probably trying to elaborate on the topic somehow, he added: 'Just look at the nonchalance on your son's face. It's as if he wanted to say: "This is nothing to me."'

This time, however, Żywny struck the wrong note.

'Why pay for lessons he doesn't care about,' declared my mother.

The horse made its last lap and stopped at twelve o'clock. I fell off and was saved. Horse riding was never brought up again. My mother rejected the phrase 'as if' on principle.

Sod that

Cry me a river.
Come on and cry, cry, cry me a river, cry me a river
'Cause I cried a river over you
 – 'Cry Me a River', Julie London

My mother remembered which neighbour dissolved into tears on the day, and who stayed silent. She'd recall that the care-taker and the democratic domestic help had cursed under their breaths.

Workers, peasants and writers mourned the Builder of Socialism. Somebody told me that they had sobbed along with their whole class at nursery school. After a few hours a problem emerged: the children had run out of tears. After a panicked meeting of the nursery teachers, a decision was

reached. Those who cannot sob any more are to do a dry wail, like so: ooo.

Konstanty Ildefons Gałczyński, himself with one foot in the grave, poor man, wrote a poem about how the rivers of the world cry for the great patron of hydrological investments.

The image of the spring flood already presaged the thaw. Soon after, in some Soviet film, political change was symbolised by a stream, a salty trickle amid snow.

But at the time my mother's cousin was almost kicked out of school because she made a carefree comment: 'Do or die!' Denunciation, scandal and investigation, imminent catastrophe; my aunt begged the headmaster not to ruin the child's life.

It blew over somehow. Along came de-Stalinisation, and Khrushchev in a corn grove. Soon after the whole story about doing or dying turned into another family anecdote.

But on 5 March 1953, on the day it happened – or perhaps it was a little later, considering all the issues with the flow of information – somewhere in the north, columns of prisoners passed each other and exchanged the news: 'Us otkinul khvost!'

The Moustache has kicked the bucket.

Snuffed it.

Croaked.

Conked out.

Pegged it.

Writer Marek Hłasko described the moment in which Stalinism ended: a performance of a play about Korea or the heroes

of labour is underway at an amateur theatre. One of the spectators jumps up onstage, interrupting the propaganda, and stabs the main character in the chest, shouting: 'This'll show you to fuck Jadźka!'*

My parents' youth started about that time. They always liked these kinds of sayings.

You're pulling my leg.

Sod this for a game of soldiers.

You'll be laughing on the other side of your face.

Fan-bloody-tastic.

Howdy-do.

Savvy?

Bugger all the way off.

And those phrases that mother used to comment on events.

'I don't want to go to school. My throat hurts.'

'We have just received health condition report number five, now get up or you'll be late.'

I can recognise the voices of people from her generation. They seem to speak simply, but they choose their words with care. And their speech always has a breathable, water-resistant lining of irony. Like the materials now used to make boots.

For some reason those characteristics disappeared in the writing of that generation. On paper, they became stiff. Pompous. And as time went by, more and more bombastic.

* *Beautiful Twentysomethings*, translated by Ross Ufberg (translator's note)

—

Words had failed them. Words had lied to them. Later those words were like intellectuals after October '56, when they made excuses for their erstwhile support for the regime. You could listen to them. You could even like them – but always with some reserve. Caution. With sympathy for someone beaten, broken and put back together from the pieces. 'With all due respect, we won't follow you blindly. You need to help us. You are our hostage.' And words really tried to help them.

Besides, they were young in an era when that meant something. The boundary of youth was still distinct.

Adults dressed, spoke, and acted differently. My parents – in their Hoffland clothes and, later, Cottonfield sweatshirts – never wanted to grow up completely. They told me to call them by their first names. So I said 'Piotrek' and 'Joanna' until we got bored of it.

They went to work, took on various serious and responsible tasks, but approached even these serious and responsible undertakings with the enthusiasm of scouts.

They were always accompanied by a shadow of unseriousness. Something scamp-like. A directness.

My mother left behind no mottoes, words of wisdom or commandments.

Too careful to present any opinion first, she exploded instead in responses. In reactions. In scorn. Always ready to intervene if someone got too stuck-up.

Extremely suspicious of words, if she quoted any saying it would come with a source.

'Mrs Władzia always used to say that newspapers don't write about decent people.'

In fact, this thought could be expanded. Decent people don't write for newspapers. Decent words aren't used in newspapers. A phrase that had found its way into print should now disappear from our vocabularies.

'Who talks like that?!' she grimaced with contempt and pity for the unfortunates whose speech had been infected.

She didn't like books and films with inspiring messages, elevated screenplays in which it turned out that it's fantastic to have Down's syndrome (her words). That love conquers illness and the sick person disappears like Yoda. Without pissing themselves, developing bedsores or needing painkillers. And that you just gotta pull yourself together. That the family will always unite.

She never accepted routine consolation. Courteous expressions paid in small change.

She hated euphemisms. Once, when cigarette packets weren't yet sullied by warnings, she caught a patient of hers smoking.

'You're going to say it's not good for me,' he sighed.

'No,' she countered. 'I was going to say it gives you cancer.'

She could be worse than the Ministry of Health (she didn't smoke herself).

'I don't like it when people lisp,' she barked at the charming old lady joking around on TV.

She wasn't a monster. She just noticed the traps of sentimentalism before any of us did.

She was furious when they started talking about the miracle of the woman carrying a child under her heart (which made my mother think of female kangaroos).

She knew what was what. She knew that when newspapers start writing about freezies, and on TV guys in suits and cassocks get maudlin about cellsies drowned in nitrogen, when they talk about those ickle embryos which open their tiny mouths to plead 'Give birth to me' – for sure they want to ban IVF.

Theoretically

One day, in Year 5, I almost scored a goal. It's a lengthy story and not worth telling. In any case, never in my life was I closer to scoring a goal than that day in PE.

I reached the penalty area. I saw the astonishment on the goalie's face. I gave the ball a shy, almost questioning nudge. Unexpectedly it agreed and, in no hurry, made its way towards the goal, and – here what I'd really like to do is add a little more, fill in the gap, write things in, just to extend this sentence and that moment. But no can do. The ball turned, bounced off the post and rolled away into the grass. Everything went back to normal.

I went home. Did some homework. The radio was playing classical music. I waited for the footsteps, the key scraping in the Skarbiec lock and the shopping bag's soft tap against the

door. I rushed to help, so that I could announce my success at the doorstep.

And this was when I made my mistake. I acted like newspapers and websites today: I amped up the headline. For effect. Out of laziness. I couldn't find a better way to express my sense of triumph.

'I scored a goal.'

'A goal?' she asked happily.

'A theoretical goal,' I specified.

What? I had done all that was required of me. I had no influence over the ball's final decision. The word 'theoretical' was also new to me, so I liked to put it to use.

'A what goal?'

'Theore —'

Then I understood my mistake. But I still didn't know what price I'd end up paying. If you swallow the vowels, the adjective 'theoretical' turns into a murmur.

'I scored a thrtcl gl,' I repeated.

'You scored a theoretical goal?' my mother repeated.

'Yes.'

'So you didn't score a goal?'

'Yes. No.' Not only did I back myself into the hole of linguistic abuse, but also into a pointless tussle with the double negative. 'Actually, I didn't score.'

'You didn't.'

I wasn't the only one who knew this tone of my mother's. Once, a patient, unfortunately not a very intelligent one, got hold of the answers to a general knowledge test. The examiners

defined the correct answers within a range, and that poor sod learned all the ranges by heart.

'How many kilometres is it to Paris?'

'One thousand to one thousand five hundred,' he answered.

'It's on a rubber band?' asked my mother. 'Paris? It gets closer and further away, does it?'

The counsellor could be rather venomous. She also wasn't the sort of person who would let go of a topic easily, so for a long time I was pursued by her scorn: 'What is it that you can do? Score theoretical goals?'

What my mother appreciated was effort, even if it was unsuccessful. She was also able to understand and forgive failure. She could suspend the sentence for lying. Forgive rudeness, cowardice and weakness. Turn a deaf ear to boasting (with difficulty). But she wouldn't allow any meddling with words.

Tar

Of all of singer-songwriter Bulat Okudzhava's songs, 'Alexander Sergeyevich Pushkin' was the most impressive. I knew it in its Polish translation. The lyrics were a small anthology of the sixties: wartime memories, the conquest of space, modest consumption and some strange longings, sentiments and desires leading towards Romantic poets, ineffectual revolutions – and Decembrists freezing in Senate Square waiting for the authorities to sort them out.

When actor Edmund Fetting performed the song, he sang about 'pedestals where there's no longer a soul'. Later I noticed that the image of the pedestals was added by the translator, which made the allusion to the cult of Stalin clearer than in the original. There was also something about rockets that 'take us away' – the first-person plural seemed somewhat excessive; it wasn't like those rockets took everyone away.

However, by the time of my childhood, space travel wasn't so impressive any more. School reading texts and toy rockets in playgrounds remained the only mementoes of the fever stirred by Gagarin's mission. Rustling nylon shirts were also no longer desirable.

The real mystery lay at the end of the 'Pushkin' song:

And I could now swear
That something will soon come to pass.

That single syllable hung at the end of the last stanza like a drop about to fall.

'What will come to pass?' I asked people older than me.

'Something,' they replied.

'A revolution?' Nothing else occurred to me in the context of Russia.

'No.'

'What then?'

'Something.'

Something. A harbinger of all future events. Concentrated matter. The universe before the Big Bang.

I was convinced this something was to do with politics. That this is what my father was awaiting when he listened to the BBC at night. That's why he glued orange dots onto the radio's scale (he produced them with some self-adhesive paper and a hole punch) and drew marks on the less jammed frequencies.

It's getting close. We'll hear it in between the crackle of the speaker. Perhaps it'll appear between the lines in the

newspaper. Or it'll be announced by a grimace on the TV anchorman's face. And on Monday they'll shut all schools and we'll be told to stay home.

My mother didn't listen. She went to bed earlier than my father, because she got up earlier. She started work at eight.

In 1927 Professor Parnell from Brisbane poured melted tar into a glass funnel. Three years later, when it had solidified, he removed the stopper so that the shiny, viscous mass could begin to drip.

And indeed – less than a year after the Anschluss the first drop fell. The second took until February 1947. It probably happened at night, or at the weekend, when the laboratory was locked up tight. Or perhaps just the opposite, in the light of day, among the hubbub of conversation and the soughing of burners, when everyone was busy and, irritatingly, nobody was watching. Parnell died in 1948. He didn't live to see the third drop descend.

In April 2014, the fall of the ninth was recorded by three webcams. That's it so far. Somewhere on the other side of the Earth the tenth drop is growing (ever since air conditioning was installed, they've become even more elongated).

I tried to imagine a drop falling.

One afternoon in the early eighties, some time after martial law had ended, I was helping my mother in the kitchen.

That is, she was peeling, cutting or whisking something, and I was reading the afternoon paper to her.

When I ran out of real news, I started making it up. First, I presented a press release about the Soviet Union being dissolved. The TASS Agency reports that, taking advantage of the relevant clause in the USSR constitution, Kazakhstan has decided to leave the union of fraternal republics. (No reaction.) Encouraged by this example, the Baltic republics have declared their independence (still no reaction) and neutrality (chop, chop, chop), others have concluded that continuing in this vein makes no sense . . . (more chopping). I was running out of ideas, but I kept imitating the language of official reports (hold on, blender noise now), and my mother still seemed completely unperturbed (buzzzz). I started to wonder whether, to enliven the plot, the situation shouldn't involve Martians.

'A fine business,' she finally said. 'What now?'

'They're saying to await further reports.'

'Aha.'

The drop was hanging there, but events played out in geological time.

Even the radio encouraged us with the lyrics of a lively song: 'Be like a stone.' Always with the minerals, the scrap, ashes and diamonds. Stones changed the path of the avalanche. In the long term, one could hope to be included in the company of cold skulls, as Herbert's Mr Cogito predicted. Altogether it's hard to consider this an appealing prospect.

Sometimes something really did happen. Waves of panic. Half-encoded messages on the phone. Rumours of devaluation. Rumours of forced conscription. Rumours of explosion. Spy satellites flew overhead. Radioactive clouds floated by.

Usually our indifference was dry like sand. It poured in between gears. It wore away the contours of buildings. It buried pyramids. All that remained was to wait.

Only during capitalism did everything speed up. The avalanche changed paths depending on what yoghurt we bought. Consumers' decisions shaped the world.

In the Billa supermarket a dozen types of cheese and yoghurts awaited. We reached for one – and that gesture, multiplied by thousands, millions of hands, built someone's fortune. Single złotys changed into millions. Slices of ham petrified into layers of Chinese marble on the walls of someone's palace. Jars of mayonnaise (mum, think of your arteries!) turned into a guarantee of the favour of politicians and the prayers of bishops.

Even ice cream in cartons paid for the opulence of weddings and divorces, charity work, the addictions of wives and daughters. Even sausage paid the kidnappers' ransom.

Capitalism provided meaning. We were all jointly responsible for all the misfortunes caused to rich people by money.

My father didn't believe in the Internet. In the evenings, he still sat and listened to the news. After he died, I took his place. My turn on listening duty. I played the know-it-all, lectured my mother. Then I was left alone. I still stare at the TV at night. Something will still come to pass.

After March '68

Before March. In March. After March. Like in March. Almost like in March. That month was at the centre of her life story. It was one more thing I didn't understand. That is, I thought I understood. I read what was required, I knew the protagonists and who had said what. I knew the stale anecdotes, the heckling with which the perpetrators of the anti-Semitic campaign were punished. Those horrible puns and jabs at Damski and Kur – see, they weren't spared, the Jewish God is just – he gave them surnames that were simply asking for an insulting play on words.

I rooted for my mother whenever she announced that she would watch First Secretary Gomulka's hanging. Of course, it never happened. Derision, repeated for years, was our only substitute for justice.

—

At some point in the nineties the first book of memoirs by children of the Holocaust was published – there were many more later. I remember an event – the word 'launch' was probably already in use by then – I remember the launch of those children of the Holocaust, a narrow room in the Museum of Literature, rustling winter jackets, the polished floor, the snow was melting off shoes, smeared on the yellowish parquet, water sank into the gaps between the woodblocks, people perched on chairs.

I knew my parents' frolicsome Jewish friends. But they were post-war. They were post-war children. Programmed to be carefree. The people who were gathered in the vaulted room seemed much older. I'd never felt such sadness before.

At the end of the grey volume there were bios. Laconic proof of some continuity. People pulled out of basements, hiding places, and monasteries put their lives back together. They finished school, found jobs, had families – new families they told things to, or kept things from.

Subsequent lines mentioned names of universities, institutions, workplaces, towns. Dates were sprinkled within each text. Every biographical note ran its own course; there was only one place where they could all still meet.

Later I saw it often. '68. The number featured in many biographies. It was the date when careers stopped in their tracks: the prosecutor suddenly became a legal adviser for an invalids' cooperative; the radio employee a pensioner. When The director died.

And in that year my grandma cried:

'Whatever for did I have these children? Whatever for?'

They were granted some extra time. Then the past caught up with them all. But it's all over and done with now. It blew over – not immediately, not completely, not without consequences, but it blew over. Leaving only fear.

We kept talking about politics

I visited my parents and we talked about politics. I visited my widowed mother and we talked about politics. That was one conversation that always flowed. I liked to torment her.

'Did you see,' I asked, 'who was on Olejnik's show last night?'

'I saw,' she said. 'Nasty little Hitlerjugend.'

(She detested young politicians even more than the old ones.)

'Oh, that's going too far. He's a very talented man.' Satisfied I was getting the right reaction, I continued: 'And handsome.'

'Idiot,' she fumed. I acted like that hadn't been aimed at me.

'Maybe so, but the leader really trusts him.'

'Very funny, that's enough now.'

'Maybe I'll vote for him.'

'Just you try.'

'You won't let me?'

'No more apple cake. No more family dinners. I'll disown you.'

<center>* * *</center>

I'd intentionally visit her during TV hours. For the hundredth time we watched those small-time crooks. Listened to their babbling. Obese, threadbare veterans of parliament. Balding party activists, former rural commune leaders, presidents of municipal corporations, deputy headmasters of schools, managers of swimming pools who had swum into the ozone-enriched waters of national politics. And the younger ones too, smooth and shiny pretenders to power, trained long enough in the art of being yes-men to lose all individual characteristics.

It was delightful to watch their trotting along the Sejm corridors. To follow their alliances, their coalitions. Register how they rose and fell.

Politics stops us from thinking about everything else. About bills, payslips, test results. About parents we feel resentful towards; children who are persistently unhappy despite everything we do for them.

Politics is beyond our influence. No use flossing or using fluoride toothpaste. No use giving up red meat and sugar. No use exercising. Power walking. Visiting the swimming pool. Regular check-ups.

We are not to blame. Politics – our equivalent of English weather.

Anecdotes

Or that boy my grandmother met in someone's flat. The boy who was forbidden to approach the window in case someone saw his funny silhouette in the pane. Who asked my grandmother politely: 'Have you heard about the ears, ma'am?' Because even children knew about the nose. Where was that flat? In which part of the city? Which year? What happened to him?

Our history consisted solely of anecdotes. The characters in the anecdote appeared only for a moment. Spoke one line. Did something funny and graciously disappeared.

An anecdote is a single point. Our history consisted of dispersed points which were impossible to join into lines.

Anecdotes are the opposite of a genealogy.

Many years later people became obsessed with creating family trees. They toured church offices and cemeteries.

Downloaded registers and baptism certificates. Browsed databases. Copied inscriptions from gravestones. Examined old obituaries. They even got into cahoots with the Mormon centre. This eventually resulted in a tree. A large diagram where nobody is a lonely stick. Every leaf holds on tight. No chance of escape.

Even if you ditch your family, cover up your tracks, wander the world disregarding your duty towards your loved ones and society, you'll still end up on your perch, entwined with lines of ancestors and descendants. We, however, had few living relatives – but many anecdotes.

Family holidays would come around. Everyone sat at the table and shared anecdotes. Each person had their designated role. The master storytellers tried out new tales. Like musicians who want to present material from the new album even though the audience is waiting for the old tracks, the *golden oldies*, stories recited year after year, like prayers. It was only years later that I realised that the phrase 'during the war, when we were being moved' – a terse introduction to a yarn about cheating hunger by reading *The French Family Cook* – referred to living in the Warsaw ghetto.

I never learned any specific dates, sequences of events, names, places of birth. But I have, many times, heard the story about the pre-war buffet at Grodzisk train station. About the transparent long johns. About the turtle soup that my grandma found herself making when she was pretending to be a cook (what were you thinking, grandma?). About how in Spain the bread is all crust. They're not trying to cheat

you, they just like how it tastes – my father's father would say with surprise (what were you doing in Spain, grandpa?). About drunk cows in Siberia (where exactly?) who had gorged themselves on waste from the spirit factory. About the funny classifieds in a Jewish newspaper (who was buying it?). About someone's superior at the gymnasium (what was her name?). About cellmates in Serbia Prison (why were you imprisoned there?). About the plumber who said 'Peekaboo!' My parents didn't take part in those performances. It wasn't their style. Not their era. The younger generation didn't stand a chance in this competition. But they laughed at the right moments.

Miranda

June. Strawberry season. Fruit pie – the first representative of the new vintage – small drops of syrup on the meringue. Round-bellied bottles of the soft drink Mirinda: the reckless Gierek has just splashed out on a licence to produce it in Poland. Grandpa, sceptical towards Gierek's new economic policy, slides his glasses down to the end of his nose, raises the metal cap to eye level, turns it around in his fingers, reads the name slowly. Removed from power long ago, grey-haired and tall, he's still the only handsome man in the family.

'I was in a camp called Miranda,' he says. 'Miranda de Ebro.'

But he doesn't elaborate.

Footnote

'Have you already told him?'

'Ages ago,' boasts my mother. 'I can't even remember when,' she adds (but of course, she does). 'He was about three and it came up completely naturally.'

Ha! There you have it. Their parents – my grandparents – couldn't do it. That's why that whole generation had to obtain their information from suspect sources.

They learned from mates in the schoolyard, in the locker room or in the playground. To make it worse that information was frequently passed on in a vulgar form, tinted by unhealthy excitement or sensationalism. Thankfully my parents are different, they openly discuss difficult subjects. They don't initiate the conversation, but when the child asks, they don't panic, just answer honestly and respectfully. They adjust their vocabulary to the child's abilities, avoiding euphemisms and

infantile diminutives. No evasion, they explain everything clearly, but without any unnecessary detail.

'We were driving past a Jewish cemetery and it just came out.'

'Oh!' the guest is full of respect.

'I told him about both his grandmas.'

'And we also said that Tuwim was one, too, for fun,' giggles my father.

Indeed, Tuwim was a lot of fun. Generally speaking, we had such fun.

I really miss my open and modern parents.

A few decades later my widowed mother will take her grand-daughter to a commemorative march at the Monument to the Ghetto Heroes. Without going into too much detail – how much can you really tell a four-year-old girl? – she will explain that this march is to honour 'the Jews who used to live in Warsaw'. My daughter will politely accept this and will not demand further information. Only around the Umschlagplatz will she ask: 'And how did the Germans kill them all?'

Inkblot

That word didn't exist. Only sometimes someone would let it slip as an insult. It appeared in school jokes, curses and nicknames. A lexical quirk. An inkblot.

A careful note in parenthesis belongs here – because, after all, the word was still stuck in dictionaries, old novels, encyclopaedias.

The main thing was that it didn't sully school textbooks. Didn't besmirch set texts or prowl about in newspapers. Didn't deface walls or commemorative plaques. The third definition in Doroszewski's dictionary: inkblot. There's even an example:

> *żyd*, n.: 1) a descendant of the ancient inhabitants of Judaea (south Palestine), who considered themselves a nation descended from Abraham and the patriarchs; 2) a follower of the Mosaic faith; 3) inkblot: 'Gustlik stuck out his tongue, sweated, made one huge *żyd* after another and sighed secretly.'

The word allowed itself to play pranks. The third meaning – Mr Inkblot – found its way into the title of the most popular children's book series in Poland. He quietly lived in school bags and on the official list of set texts. The red-haired protagonist raised no suspicions, and the author's name was given to kindergartens and playgrounds.

It wasn't until democracy came that right-wing councillors twigged and put an end to those vagaries.

In the world of my childhood there were no Jews. That is – they were allowed only if they kept their heads down. Within their four walls, in small groups, at home, at the cemetery and in the past.

Censorship kept the secret. Good manners were on guard. And sometimes also politeness. Mores. Culture. Tact. A dislike of ostentation. I was talking once to a deceased artist's friend.

'Was he Jewish?' I asked.

'Absolutely not.'

'Then why did he bequeath all his works to the state of Israel?'

'I don't know. That was his business. What kind of question is that? The subject never came up. Never.'

Precisely. The subject never came up. And by the way, even if someone was, you know, then they always spoke Polish. Spoke it beautifully, knew Słowacki's *Balladyna* and Sienkiewicz's *Trilogy* by heart:

'Grandma, did anyone at home speak Yiddish?'

'Of course not. Everyone was educated.'

And a common refrain:

'I don't say I'm Jewish, it might make people uncomfortable,' my elderly relative told me.

God, how horribly this annoyed my mother. So she would grab that word and stab it into conversations blindly. Grandmas and aunts goggled.

'That's hardly appropriate, Joasia. What can you know about it? It doesn't affect your generation. It doesn't affect you. Let bygones be bygones. Would you like seconds?'

But that didn't work with her. She'd get involved in unnecessary discussions. My mother's ethnic rows were real masterpieces of the genre. I remember a certain portly man launching into his standard-issue anecdote:

'I had the dubious pleasure of seeing Bergen-Belsen the day after the liberation,' he would start, 'and those tiny little Jewesses . . .'

The guy just wanted to tell his best story, his number one hit of holiday yarns. He always started with that 'dubious pleasure' and charged on. What on earth possessed him to talk about 'tiny little Jewesses' in front of my mother? He soon regretted it. She tore the bastard apart, publicly, tore him to shreds in the foyer of the architects' union hotel. The vaulted ceiling echoed with his protestations for a long time after that:

'But what's offensive about that? How else am I supposed to say that a Jewess is short?'

This was how she scandalised decorous ladies. Snapped at teachers. Suppressed shop assistants. Silenced anti-Semitic

taxi drivers. She didn't react when we moaned: 'Why are you doing this?'

She sprang into a fight like an oversensitive Semitic rhinoceros. A furious referent of an unspeakable noun. Rude Old Jewess.

'Mum, enough, let's go, leave it, people are staring.'

* * *

She had many flaws, this mother of mine. She was a so-called 'difficult person'. Like a task for extra credit. Like the cryptic crossword in the Saturday paper. Friends claim she gave it to you straight. At times she did, at times she didn't. But one thing is certain: when she had something to say, nobody could silence her.

Plaque

Later, the word started to appear. Slowly and carefully at first. A commemorative plaque was unveiled in the town of K.

Sometimes foreign tour groups turned up. Our economy was in need of foreign currency. Tourists alighted from shiny coaches. They walked around. Looked in. They might start asking questions.

So in 1983 a plaque appeared. It was set in the wall next to the back door of the cinema, where the projectionist would have his cigarette (with the muffled sound of dialogue and the projector's hum coming through the wall).

Well, where were they supposed to hang it? There wasn't space at the front: the display case that announced the listings was there. It felt silly to move the case. Put the plaque next to it? How could they? Here – victims of fascism, there – *Chingachgook the Great Serpent* (GDR, U rating).

So they put it at the back. The text – I can imagine how long they deliberated over the correct wording – mentioned the town's former residents. 'Former', as if they had been dismissed. As if they had been retired from their posts as residents.

In memory of the three thousand Polish citizens who were murdered by Nazi occupiers during the Second World War, former residents of Jewish descent.

I wonder if the stonemason was paid by the letter.

Adjectives are longer than nouns. And the whole sentence was as long as a pole, a bamboo fishing rod. A mechanical arm with many joints, objects and attributes. Anything to keep that word as far away as possible.

So many letters. So many layers. Only at the end did they dangle, those . . . Who? Residents. Former resident and former occupier. Apparently, there was a time when these two didn't get along.

That other – unacceptable – noun would have been like an inkblot. A balloon filled with paint hurled at the white stone wall. The wall of the cinema. The wall of a former synagogue.

The following years were to bring concerts of Klezmer music. Restaurants with matzo balls. Stalls and stands. The sale of Dead Sea toiletries. Oil paintings (colourful houses and black patches of long coats). And figurines of a Jew with a coin. Jew with a fiddle. Jew with a bucket. The timidity had passed. And everyone had a share in the profits.

Apart from the former residents, of course.

The dictator

It was the time of perfect television. There were no remote controls. Maybe somewhere in America, but they hadn't made their way to us. I remember reading a crime novel whose translator had a moment of ingenuity: the bored gangsters zapped between channels with a 'lazybone'.

Sometimes the TV controllers decided to gladden the audience with a Disney or Chaplin film. Charlie was never boring.

One winter holiday they showed his film *The Great Dictator* (1940): two crosses on red flags. The tyrant and the tyrant's double. The good-natured barber. The dance with the globe. The lofty speech with a sunrise in the background.

Out of all of these scenes, one shot impressed me the most.

Of course I knew that it was just a set built in some Hollywood studio. It didn't matter. The filmmakers might

have been drinking gallons of orange juice and whisky, driving around in Chevrolets, playing jazz and wearing sunglasses – but they recreated the landscape after a pogrom flawlessly.

Blood. Broken glass. Feathers. Strewn objects. And the boarded-up shop windows. Letters on the wood, white lime, JEW. I read this phonetically – something between a moan and a yawn. Later I thought it's code. A letter swap. Like in *A Space Odyssey*: IBM hidden in HAL.

A European landscape. The dawn after Kristallnacht. Who came up with that name? The Snow Queen? Kai! Kai, where is your brother, Abel?

Later, in an album of Russian painting, I saw a drawing that was similar to this. Street-level view. A person pressed to the pavement, hugging the ground, surrounded by yellow walls. Lots of feathers and blood. Not much glass. Maybe glass belongs in rich and civilised Western cities. Maybe this gave rise to the illusion that in glass houses nobody throws stones.

I also made my own drawing. Mine showed an empty street (which saved me the bother of drawing figures). Walls of houses with brick patches. Wooden boards. A cart.

I took the general mood from the film, but the details were based on thorough observation. I recreated the entrance to the closest grocer's, with its pyramid of empty crates, the peeling door frame etc. I got it in one. That damp hole where we bought sauerkraut and potatoes used to house a kosher slaughterhouse before the war.

Finally, across the walls I painted the words JEW, JEW, JEW and gave the picture to my mother as a gift. I always knew how to please her.

Hello, Dolly

I have met many virtuosos of silence, but only one aunt reached true mastery. The word 'aunt' doesn't reflect the true relation. Kinship was often distant, complicated, sometimes as thin as a thread. Perhaps there was none. Any person known since before the war was entitled to an honorary title. Everyone who remembered that time became my mother's family.

An expert in camouflage, with bottle-blonde hair. She didn't look her age.

After the war she covered her tracks. She got baptised. Became a Catholic. Became an Evangelical. Became a vegetarian. She went to an Orthodox church. She went to the other end of Poland. To the mountains somewhere, the seaside, the recovered territories. I don't know, but even now I feel that I'm revealing too much, committing unforgivable betrayal.

The honorary aunt had masses of energy. She went about her business all around Europe. Sometimes she visited my mother.

Once she was over for a few hours. My father was supposed to give her a lift to the airport. The musical *Hello, Dolly* was on. She had chosen the train she took to us specifically to make it in time for *Hello, Dolly*. She sat in front of the TV. She was saying something, but didn't take her eyes off Barbra Streisand.

'Great girl,' she repeated. 'Isn't she such a great girl?'

Barbra was her victory. She stood for the triumphs of Israeli weapons, seawater desalination facilities, orange groves in Jaffa and tractor factories.

I think Barbra was the only person my aunt could be honest with. She didn't have to pretend in front of her. Barbra knew everything, because some part of my aunt became embodied in her. As if she lived on her behalf, carefree.

> I said hello, Dolly,
> Well, hello, Dolly,
> It's so nice to have you back where you belong
> You're lookin' swell, Dolly
> I can tell, Dolly
> You're still glowin'
> You're still crowin'
> You're still goin' strong.

Many years later I found a YouTube video of an old show – a televised American concert for whichever anniversary of the

State of Israel. The American Jews really did give it their all. They sang, played music and told jokes. It all culminated in – ah! – a live phone call between Barbra Streisand and Golda Meir. She called the former Prime Minister's landline from the stage.

'Is this you, Golda?'

'It's wonderful to hear your voice. I wish I could see your face.'

'Modern technology has not gotten us that far yet.'

'On the ninetieth birthday I'll do that!'

Golda, the Jewish grandma, was looking down from an enormous screen hanging above the stage. Filmed at her home, she couldn't see Barbra, but she could hear her sing the Israeli anthem. That anthem you can't march to because it has the melody of a Ukrainian lullaby. (Everything will be all right, it seems to say; lullabies usually promise that everything will be all right.)

I had a feeling that Golda Meir had the same gaze, that she looked at Barbra like my aunt did. My aunt who was not an aunt at all and was buried long ago under someone else's name, with someone else's biography, in a strange city, I don't even remember which one.

I should have sent a link to that video to my mother, but I didn't in the end, because we'd had a falling-out.

Caretaker

'Piotrek's parents are ageing well,' my mother remarked once, when I was small.

'And your mum?' I asked.

The famed honesty of children isn't worth shit. Children are cunning like a tabloid's legal department. They always know when to use a question mark and prevent future lawsuits: 'We were just asking!'

'She isn't.'

One grandmother was well-organised.

The other grandmother lived in chaos, sadness, wafts of smoke (she smoked Klubowe). Objects were jumbled up in every nook and cranny. Furniture was covered with the tacky dust produced by gas cookers. You could scrape at it until wood grain and a trace of French polish showed underneath.

Even the spines of her books made for depressing reading: *Auto-da-Fé*, *Every Man Dies Alone*, *The Black Obelisk*. She'd sit over a crossword or a novel from the library. With time their grey paper jackets were replaced by plastic covers, but she died before they started pasting in barcodes. My mother's mother.

The other grandma always remembered to put a checked tablecloth under the runner and prepare fruit for ratafia.

This is what my father's mother was like. Loyal. Loyal to power. Loyal to the world. Someone once wrote that she always looked like a well-groomed teacher.

It's true, some people – no matter their profession – behave like teachers. Or like someone showing foreigners around a workplace. An estate agent recommending a house by the rail tracks.

My mother couldn't forgive her this resourcefulness. While at the same time she resented her own mother for her helplessness.

In 1985 or thereabouts a fragment of the film *Shoah* was aired on TV – the bit with the Polish peasants standing outside a church and with the Pole who says 'if you cut yourself, I don't feel pain'. They showed it right after the evening news with appropriate, outraged commentary. 'Look how they insult us,' they said. 'How horribly they insult us. All they do is insult us. Any opportunity, and they insult us. We saved them and they're just waiting to insult us again.'

My mother's mother watched the film and didn't say a word.

My father's mother was outraged. She resonated with the TV outrage. She supported it, loyally harmonising with the outraged presenter.

Later I saw this co-outrage many times. It was the relief of finally being able to join the community of the wounded, of warming yourself at the brotherly fire of shared anger.

My father's mother declared that Lanzmann's film was biased and unjust. It was the first time I'd heard her talk about the occupation and go beyond her default set of three anecdotes.

And then, in a tone meant to settle the matter, she cited her conclusive argument:

'Once I bumped into the caretaker of the tenement where I lived before the war. I'm sure he recognised me. He must have recognised me. And he walked right past me.'

Space

They were supposed to print the short obituary in a big box. Laconic words, surrounded by blank space. A graphic image of sadness and silence (plus it wouldn't look stingy either).

Apparently, that day the deceased were plentiful, because the box shrank. The margins were lost. Grandma's farewell was a small measly rectangle squeezed in somewhere at the bottom of a column.

'They robbed her!' my mother cried. 'They took even that away from her. They didn't even leave her that white area. They stole her air.'

'The term is "space".'

'Those damned whores at the newspaper stole her space.'

Annihilation

One day, my daughter asked me:

'Why did they all have to die?'

I knew this question would come at some point, but why already? Why so soon?

'You know,' I started. 'People — People sometimes —'

'People?'

'Some people.'

'So it's because of people?'

'Because of people. Yes. Man's inhumanity to man. I mean. Sometimes. In groups. People. Sometimes.'

'Not because of a meteorite?'

'A meteorite?'

'You don't believe that dinosaurs became extinct because of a meteorite?'

'Of course, a meteorite.'

The next day I told this story at work – I was working at a right-wing newspaper. Everyone had a good laugh, and then one colleague asked me:

'But you told her that Polish people had nothing to do with it, right?'

PART 3

LAUGHING AT THE RIGHT MOMENTS

PART 4

LAUGHING AT THE
RIGHT MOMENTS

My mother calls me one day. We've had a falling out. I don't remember why.

'You need to come over,' she says.

'I'm doing something,' I reply.

'Then come when you're done.'

I know that tone. She must have a strong card. Stronger than usual. So I go.

Her friends are already in the hallway. It's a constant in our life. When something happens, the friends come. The Greek choir. The general assembly. An urgent meeting of the executive board. They sit around the bed. They sit around the table. They gather around the phone. Make calls. Look for ashtrays. Make decisions.

This time it's different. The friends lower their voices. They hug me. They leave.

The only one left is my mother, squeezed into a corner of the purple couch. There's a stack of newspapers nearby. She silently hands me an orange sheet of paper.

I know without reading.

I imagine the doctor. He looks at a photograph, types a description on the keyboard with his index fingers. In a moment he'll click print, reach for the sheet of paper. But the orange ones are kept separately. Maybe they have a whole ream. Maybe just a few sheets in a paper wallet, stuffed at the bottom of the drawer in embarrassment. Or you have to ask someone.

'Nurse, have you got the orange paper? I'll need the orange paper.'

Maybe it should be red, but then you wouldn't be able to read the letters.

The doctor puts the page in the printer. He listens to the printer head spitting out words. End of line. Rasp. Again, from the start. One letter after another. Loom shuttle.

Then the orange sheet of paper wanders from hand to hand. There are many pieces of white paper and that single one among them. It hisses when touched. Burns the nurses' fingers. Finally ends up here.

Suddenly my mother starts to speak. She says that her father shot himself.

'I never told you about that. I wasn't home. They came to school and told me. I could never. Tell you. Anyway, someone like you must have guessed. I stopped doing well at school after that. All of a sudden everything became so difficult. I couldn't

understand anything, but they still gave me good grades. They gave me good grades because my daddy had died.'

Then she adds that there were all sorts of communists. That they never really trusted her father. That they always made him feel like he was worse than them.

'Stop it,' I say. 'Maybe you'll pull through.'

'Really?' she asks.

It was like a forgotten official letter. An envelope thrown into a drawer. A formality we weren't told about. Others would remember, pay, collect receipts. We had accruals for an overdue payment. The time bomb of penalty interest.

But yes, of course, I knew. I think I always knew. Since the day when I first saw photos from the funeral. In an envelope with the press agency's pink stamp.

Grandma was there with two children. At first, I didn't recognise them. Grandma stood in a weird sort of way, turned sideways. Her eyes were terrified. So were the children's eyes. So were my mother's eyes.

It's always been within her. Now she's sitting sideways too, in the corner of the couch.

'Maybe you'll pull through,' I repeat.

'You think so?' she asks, too eagerly.

I think she was afraid.

'I can hide one child somehow,' she'd say. 'I couldn't manage two.'

She came up with geometric speculations which involved: train, platform, bundle with remnants of belongings, strength of hands and pressure of the crowd. The crowd presses forward, the grip weakens, the crowd presses forward and separates her from that hypothetical other child. Or from me. And everything is black and white, like the most outstanding shots of the Polish Film School.

My mother's fears were dynamic. They were associated with haste, tussle and chaos. With the necessity of making decisions, choices, mistakes for which one would come to pay.

She had no stationary anxieties. In her fears – at least the ones she talked about – there was no room for hiding places, wardrobes, attics and shallow basements.

The lives of my mother's grandparents and uncle – she never met them – ended in some bunker. Or perhaps in a doorway, in the courtyard, on the street.

Maybe they came out of their own accord. Flags. Gunfire. They'd thought it was over. Anyone can make a mistake. After the war grandma looked for traces. She found enough to stop looking and never mention it again.

They just disappeared that summer. All three of them. If it had happened a few months later you could have put it down to exceptional bad luck – they succeeded for so long and then, just before the end ... But no. They disappeared six months before the liberation, along with half of the city. Nothing exceptional there.

Towards the end of her life my mother made sure that the disappearance was noted in the central archive of the disappeared.

She filled out foreign-language forms. She even gave them an approximate date of death, 1 August 1944, as if she wanted to somehow associate them, those dead strangers, with armbands, barricades, jaunty songs, everything that they had no part in. They stayed like a blot on the landscape of a patriotic tale. Why poke around in it. But my mother's fears had nothing to do with bunkers, or street fighting. They were about a frantic escape.

The last train. Always the last train, as if there were no earlier ones. The last position on a list. The last name, mercifully added at the very end. Come with us. No, you'd better stay. We have one more place. We're all full up. There's still plenty of room. Stay with your parents. Come on, hurry up.

She had a lot of anxieties. A news story in the paper, a name in an index, a word heard on the radio were enough for her to stiffen suddenly.

But she knew how to frighten in return. She considered fear a basic pedagogical tool. Perhaps correctly.

After her death I found a gold coin. For the blackmailer.

One day, my mother takes too much morphine. When we find her, she says matter-of-factly: 'I'm not having a stroke, I didn't break anything.' And then: 'But I do need the hospital.' And then, suddenly, she says '*yes*' in English.

'*Yes.*'

'What?'

'*Yes, yes.*'

'Why are you speaking in English?'

'*Body language.*'

'"*Body language*" what?'

'Be quiet. *Yes.*'

'Want some water? You're high.'

'*Yes.*'

'More?'

'*Yes.*'

'Why do you want to speak in English? You don't know English.'

'*Body language.*'

'But why?'

'Quiet! . . . How long have we been tapped?'

'We haven't.'

'The iPhone was listening to us. They know now.'

'Don't worry about it.'

'Are they coming for us?'

'You haven't done anything wrong.'

'*Yes!*'

In an ambulance you don't need to use seatbelts. That's logical: the worst has already happened.

'Are you family, sir?'

'Yes, I've got her medical records.'

'Keep hold of them. Someone will have a look.'

The part of the hospital where ambulances arrive looks like the back door of a supermarket. A driveway for delivery trucks.

When we finally make it to a ward, a doctor is standing behind the counter. She assesses the delivery. Looks at the papers.

'Home hospice? They're bringing them in droves today.'

The guys in red overalls shift their weight from foot to foot. The doctor freezes, motionless like a lizard. There's no room. Nothing she can do. She can't help us.

The reds don't want to give in. It's a warm night. They don't want to spend it meandering from hospital to hospital with shady cargo.

A discussion begins. One of the reds says something about the hospital and its referral levels. The doctor says that he shouldn't lecture her.

Basically, I could know her. We could have mutual acquaintances, be regulars in the same places. She might be someone's sister, cousin, friend.

Now I just need to say something and she'll notice I'm here. The horizontal shape on the stretcher – the lump covered with a beige blanket – that problem – will turn out to be human.

Mother has been teaching me this my whole life. Training me for this. It's time, this is the moment. I have to try. Faithful mother tongue, I used to put something before you – what is it that Miłosz said? – come on, help me now, when I need you.

I read somewhere you need to maintain eye contact. Or is it the opposite, that you shouldn't maintain eye contact. Anyway, something to do with eyes. And that you need to humanise the victim. Yes, that was in *The Silence of the Lambs*. When push comes to shove, you can only count on crime stories.

'You know,' I begin, 'I'm also a supporter of euthanasia . . .'

(No reaction.)

'. . . but must we start with my mother?'

(No reaction.)

This is also from some book. The doctor taps at the keyboard. She's looking for a space. I have the illusion that I'm

at the cinema, the ticket seller is about to turn the monitor towards me – red taken, green free, screen at the top; maybe something in row 12 then, in the middle.

'Her name is so-and-so. Even yesterday she was in good shape. Completely independent,' I explain quickly and add: 'She's a very intelligent person.'

As if I'm talking up something for sale. Come on, girl, take pity on us. You won't regret it. Like during the occupation: officer, let me live a while longer. Mister German, sir, that glass eye of yours has such a human gaze.

We wait. The doctor calls someone. She picks up a few phone calls. The paramedics are smoking outside. All the doors are open. There's the buzz of the radio, a dispatcher's distorted voice.

The doctor softens.

'Personally, I'm against hospitalisation in cases like this,' she says.

'I understand, but my mother asked to go to hospital . . .'

'You do know what stage this is?'

'Yes, but I meant to say, she suddenly became very uncoherent—'

'Incoherent.'

'Incoherent. That's what the doctor at A&E said, but the day before yesterday communication with her was still normal.'

'Well, that was the day before yesterday,' she shrugs. 'But now . . .' She pauses.

She didn't bat an eyelid when she wanted to send the patient away, but she's embarrassed to say 'your mother is

dying.' Good old Polish language. In the country of diminutives a living person can be treated like a corpse, but you absolutely need to add 'mum' or 'mummy'.

'Your mummy is on the home stretch, so to speak.'

She hits that keyboard of hers one more time. Then she admits my mother to hospital.

I can't believe I've managed to convince her. Later, I learn my mother's friends had persuaded someone more important.

It's better in the morning. A doctor appears at her side.

'And what happened to you, madam?' he asks jovially.

(No reaction.)

'Do you know why you're here?' repeats the doctor.

'Probably for the sins of my ancestors,' replies my mother after some reflection. Then she adds an aside, just to me: 'That's him told.'

Indeed, that's him told. Bravo. You've done it again. The guy raises his eyebrows. Lifts his eyes away from his clipboard. Gives you a look – actually what kind of look is it? – of surprise, astonishment, esteem? Maybe he'll even remember you. You're no longer some parcel stealthily deposited at the ward. This was what you'd wanted. Your gift of the gab got you this.

—

'Where's Piotrek?' my mother asks.

'Well, he's dead.'

'But he should be here at a time like this,' she says.

Even now she won't accept easy answers. Still won't acknowledge the workings of force majeure. If he'd wanted to be here, he would have come. Death is no excuse.

'You're dressed like an idiot,' she changes the topic.

'I'm dressed normally.'

'I need to talk to you. No yadda yadda. I need to tell you what I really think of you.'

'I know what you think of me.'

'You were here this morning and you didn't even check in on me. You were walking up and down the corridor and singing "Grandpa Was at Tobruk".'

'You overdosed on morphine, remember?'

'You were all walking up and down and singing about Tobruk. That woman was involved too.'

'You were imagining things.'

'You can't fool a mother's eyes, especially not a Jewish mother's,' she says and then adds in a louder voice: 'Let them hear, so what?'

'I wasn't here earlier this morning. Listen, did you bring me up to wander around hospitals singing war songs?'

'Unfortunately, it appears I did.'

—

And that evening:

'I wait for you all day, and you leave as soon as you've arrived.'

'I can stay.'

'Oh, I won't keep you. I'm in for a fun night.'

'Are you sleeping badly?'

'I am.'

'Are you waking up?'

'I do wake up, unfortunately.'

She comes home, but she's furious.

Once, a long time ago, a GP didn't give her the right diagnosis. He should have recognised the illness, but she lied to him through her teeth. Then she told us that it was nothing serious. That it was age-related. That some medication, supplements, therapy at a specialist clinic that used some unique Israeli method were going to be enough. We believed her.

She'd twisted him around her little finger, that good soul, the qualified doctor.

Later, after her concerned friends dragged her for some tests, and the diagnosis was clear, she developed a sudden and deep affection for that doctor. She wouldn't switch to anyone else, not for anything.

'He'll write me any prescription!' she crowed.

'He always picks up the phone!' she crowed.

'On the double,' she crowed.

'At once,' she crowed.

Because He's Got Pangs of Conscience, she added.

Because Now He's Feeling Guilty.

My mother's speech used to resemble a ransom note. An utterance made of cuttings. Catchphrases. Pseudo-quotations. She had words for every occasion. Used them like a set of tools. A screwdriver for every screw. A key to every lock.

Out of these words she built impressive constructions. Compound sentences with masses of subordinate traps and pitfalls. Battle-plan sentences. Diagrams of war operations. She could ambush any adversary. Outmanoeuvre them. Attack from the flank.

Now we're standing around her.

'I hope,' she says, 'that one of my relatives. That one of my relatives deigns to . . .'

(We're standing around her, the three of us, but she's not addressing any of us directly. She is shaming us in front of an invisible audience. She hopes that one of her relatives deigns to. Normally she'd add 'kindly': 'I hope that one of my relatives kindly deigns to.')

'I hope that one of my relatives brings to that woman's attention . . .'

(That woman's! Attention!)

'Brings to that woman's attention that . . .'

(She's forgotten. She's missing a word. She doesn't remember how to say 'a drink', 'tea', 'coffee', 'hotter'. She doesn't remember the carer's name, but she can still terrorise us with the tone of her voice.)

'I hope . . .' she repeats.

(Emphatically.)

'That one of my relatives.'

(One of them. Whoever.)

'Of my relatives . . .'

(A reminder of duty.)

'Deigns to . . .'

(Deigns to – is so kind to – is willing to – does me the courtesy.)

'That woman . . .'

(That dumb, slow-witted woman. The carer that we have brought here. The carer that's good for nothing. That we probably chose to spite her.)

'To . . .'

(To what?)

'. . .'

(She doesn't remember. She doesn't remember.)

'Never mind,' says my mother. 'It doesn't matter.'

And she falls silent. Stops talking to us. She can't risk it. Silent, she regains her control over words.

'It's like you've gone back to childhood,' I whisper, 'like you have a nanny again. Does she remind you of her? Does she remind you of Mrs Władzia?' I ask. 'Maybe just a little?'

There can only be one answer.

'Not at all.'

From then on, the flat is filled with the carer's voice. She talks to my mother in a Polish-Russian-Ukrainian Volapük.

'In hospital: bad. Home: better. We say: alone master, alone khoziain.'

'Her I gave soup. Ate little. Only in morning little . . . And did poo. Her I gave prune when she did.'

'I sleep not so strong any more (when she call, I hear).'

'Give God so all is good. Give God.'

'Hello? Can you hear me? How are things?'

'. . .'

'The weather was nice today. Lotka did a science experiment with a balloon in her after-school club. It went very well.'

'Yeah.'

'Did you say "yeah"?'

'Yeah.'

'The weather was nice today. We walked home from school. A new shop's opened nearby. They were giving away balloons and chocolates. Are you there? Say something. Say "yeah".'

'Yeah.'

'They sell ice cream. But not tram tickets, apparently that doesn't pay. Can you hear me?'

'. . .'

'Are you tired? Shall I leave you alone? The weather today
. . . The weather was beautiful. We walked . . . Shall I leave you
alone?'

 '. . .'

 'Sleep well then. Goodnight. I'll come or call tomorrow.'

 'Goodnight, sweetheart,' she says loudly and clearly.

She doesn't read *Gazeta* any more, but she still keeps it to hand. The weekend edition, creased and fat because nobody's thrown away the inserts. A glossy leaflet featuring a range of lawnmowers peeks out from between the pages.

The TV's on.

'What's she called, this actress?' I ask.

'. . .'

'Is she the one from *I Love You, Mr Sułek*?' I ask.

'My dear.'

'What?'

'Mr Sułek my dear.'

'What's her name then?'

'. . .'

A moment passes.

'Lotka's started jogging,' I say.

'. . .'

'The day before yesterday she ran to the park.'

Laughter.

'So we've got new expenses, because it turns out you need special shoes for running. She was horribly sad that she had to run in her not-very-special trainers . . . She was making a face, you know, like a hungry child looking at marmalade. So we couldn't handle it and Marta took her to buy the shoes. But it's awfully complicated business. The guy at the shop started asking what distances she runs, what sort of surface . . . And she's only run once so far, to the park and back, and she didn't really remember what the ground is like there.'

'. . .'

'So they just got her some pink ones.'

Laughter.

Until recently my mother and daughters would take trams and buses across the city together. All so they could choose, after many dramatic moments of deliberation, the right plush toy (a meerkat in green trousers? A macaque in a Basque beret?) and return home in triumph.

On the way they always had some kind of adventure. They stopped off at clay modelling workshops, theatrical shows, festivals. One day they joined a Free Hemp march, which my mother had mistaken for a gardening fair.

But it would have been dishonourable to withdraw. So while they marched she explained to her granddaughters

what it means to legalise. And that drugs are evil. 'Then it's good they're forbidden,' one of the children said, and then grandma had to patiently explain the paradoxes of the liberal world view.

The TV is still on, but nobody turns on the VCR and the film about the separated twins. One of my daughters sits by the bed, patiently trying to tell a joke. A great joke she read in the school paper. The paper costs one złoty and is extremely popular with Years 1 to 3. Each issue contains lengthy articles, e.g. 'Titbits about Georgia', 'Easter customs in our region', but above all: a collection of jokes sourced from the Internet.

'So a bunny goes into a shop and asks: "Have you got any cheese?" And the grocer says yes, so the bunny buys the cheese and leaves. And the next day he comes in and buys cheese again. And again the next—'

Laughter.

'Wait, granny. And finally one day the grocer asks: "Why do you need so much cheese, bunny?" So the bunny says, "Come with me." So they go to the lake and the bunny throws the cheese into the lake—'

Laughter.

'No, no, not yet. The bunny throws the cheese into the lake, the water bubbles, and the grocer asks: "Who lives in there, bunny?" And the bunny says: "I don't know, but it really likes cheese."'

Laughter.

'And do you know the one about the brunette and the blonde, how they fell out the window, and which one reached the ground first? Apart from that I only know: knock knock, who's there, orange.'

Laughter.

We're out of jokes. We go home.

'We'll come by again soon,' I promise.

In the afternoons, friends are on duty. They read aloud to her. I go sometimes. They tell me how the shift went.

'She didn't speak today,' one of them says, 'but when I read to her, she laughed.'

'At the right moments,' my mother speaks up suddenly. 'I laughed at the right moments.'

Later we'll realise that this was her last sentence.

Often when I visit, a TV series is playing. Sometimes it's the Ukrainian news channel. But when I arrive the carer grabs the remote and switches over quickly.

The room's hot.

Betty is putting on an American accent in the Polish series *The Ranch*. The moustachioed uncle and his tiny factotum, a toady who looks like a cricket. I remember that actor, he once sang a song about a cricket. Or maybe it was an ant. Father Mateusz cycles across the frame. The carer smiles when she sees him.

'I went there once,' I say, 'to that city. It's Sandomierz.'

My mother says nothing. She's sweaty. On the screen a good-natured housekeeper appears, a lilting salt-of-the-earth woman. Common sense itself. The fount of folk wisdom. There's a character like that in every series.

—

Back in 1984, in one of the episodes of the crime series *07 Come In*, the role of the housekeeper was played by Ryszarda Hanin. Wearing an apron and a headscarf, she convinced the reactionary parish priest that it'd be in his own best interest to collaborate with the police. This incensed my mother.

'That one's always on the right side,' she snapped at the screen.

Ryszarda Hanin had already made a call to arms over the microphone at the wartime radio station in Kuybyshev. There's mention of this in *Shielding the Flame*, Hanna Krall's book about the Warsaw ghetto uprising. That in Kuybyshev they jangled weapons and encouraged people to fight. Remember?

Things had been better only recently. We watched *Father Mateusz* on TV together. I kept guessing who this episode's killer was.

'Shut up,' my mother said. 'Idiot,' she added.

She was showing off a little in front of the carer. I was showing off too. Now she doesn't say anything. Her eyes are black. There are beads of sweat on her skin.

They show the series over and over. All the way to the last episode and then again from the beginning. But in the wrong order. She leaves. He falls in love with someone else. But later they'll be together again. Characters disappear. Reappear.

Sometimes they return as memories. Haunt their relatives as ghosts. Time runs on and back. Jerks like a stuck elevator.

'Not all priests are that nice,' I say to the carer.

'Will be war,' says the Ukrainian. 'You here don't know Russkis.'

'Your mum's condition is deteriorating,' says the doctor. 'She's absent, spacey; today I had difficulty getting her to answer simple questions,' she elaborates.

I feel like I'm at a parents' evening.

'In my opinion,' I try to defend my mother, 'she understands everything, she just can't be bothered to reply any more.'

Somehow it's easier for me to think that she simply no longer wants to talk. That she's in control of the situation. As ever.

'Fatigued by the illness? Yes, it happens,' admits the doctor. 'But you understand, don't you?'

'I understand.'

'The departure has begun.' She wants to be specific. 'Your mum is departing, do you understand?'

'I do.'

'It has already started. You understand? It's started. You understand? It.'

The ambulance is here again. Three guys. Lots of red Gore-Tex. A rattling stretcher on wheels.

'But I know you,' I say. 'You've been here before, last summer. You told me about your dad.'

The paramedic avoids my gaze. Maybe they're not supposed to talk about how their parents died. Or he doesn't want the others to know.

'I'd like to see the last hospital discharge documents. The discharge. Have you got the discharge? ID, please. A little jab. I'll check the temperature. The blood pressure.'

Fear.

'We can hospitalise,' says the one I don't know. 'We can hospitalise, if you want.'

'No, we don't want that.'

'Tick this box, then, please, consent not given, sign here.'

The paramedic who fed his father like a baby, first with a teaspoon, then from a bottle, gives me a sign. He nods: you're doing the right thing.

'No hospital would take her anyway,' he comments quietly.

'Sign here too. And here.'

'We're not going anywhere,' I tell my mother.

The morphine pump murmurs.

'Mister Marcin, she's moaning so awful,' says the carer.

Don't you worry.

There. There. There.

Don't be angry now. Don't worry now. Don't be afraid now.

Now, now.

But I love you.

Everyone loves you. Everyone loves you. Everyone loves you. Everyone loves you. Everyone loves you.

Don't worry now. Don't be angry now.

Don't be afraid now.

I know now. I understand now.

Don't be afraid now.

'I'll leave you the number, sir, if it's before 6 a.m., give them a call. They can give you night-time assistance.'

I call them the following night. I call at 4 a.m.. Two hours later ('We'll come in two hours, it gives you some time with her') a young woman appears. She's wearing a hi-vis vest that says 'Doctor'.

'Is this your last home visit today?'

'Yes.'

Night-time assistance. But it's already morning and there's nothing to assist with.

The doctor leaves some forms. The carer calls the Ukraine. Then she leaves. I'm alone. I'm alone with the body. I don't look in that direction.

I can hear the first trams. I feel calm, like when you look at a solid, finished piece of work.

'*Well done*, mum.'

'*Yes.*'

The hearse is outside. It's burgundy ('so nobody gets sad' – my mother would have said). It has a logo on the side. A branch and words in Latin.

The driver shuts the door. Suddenly it occurs to me that maybe I should give him some money, a tip or a bribe, that there must be a rule for this that nobody's told me about.

The guy lowers the window a little.

'Wait,' I say and give him fifty złoty. 'Just no jolting, please,' I add, because I feel I should say something.

Then nothing, until the day we walk into her flat carrying two boxes of wine and some mineral water and fruit juice for the wake, now called 'a farewell' or 'drop by after the funeral'.

The Wi-Fi network still hangs in the air. The neighbours see the name in their phones and tablets – but now only I know that it was the name of her childhood dog. What was its magic formula? Of course: It wasn't a mongrel, but a dachshund-Newfoundland mix. With webbed toes.

Got to air out the flat. Got to turn off the router. Got to get rid of these things. Make calls. Place a classified ad. And then keep on living.

But also, don't forget:

Once opened, store containers of coffee in the fridge.

Cut the ends off bananas.

Be generous with garlic in salad.

From time to time tell it like it is. Not always, but often enough that they're afraid of you.

That's it.

The books I kept

Jane Austen, *Emma*, translated by Jadwiga Dmochowska, Warsaw 1963.

The Children of the Holocaust Speak, edited by Wiktoria Śliwowska, Warsaw 1993.

Lydia Flem, *How I Emptied My Parents' House*, translated by Elżbieta Burakowska, Warsaw 2005.

Anne Goscinny, *Dad*, translated by Magdalena Talar, Cracow 2013.

Marek Hłasko, *Selected Works, vol. 5: Beautiful Twenty-somethings*, Warsaw 1989.

Venedikt Yerofeyev, *Moscow-Petushki. A Poem*, translated by Nina Karsov, Szymon Szechter, London 1976.

Konstantinos Kavafis, *Che fece . . . il gran rifiuto*, translated by Zygmunt Kubiak, in: Konstantinos Kavafis, *Collected Poems*, Warsaw 1995.

The Book of Tasty and Healthy Food, joint publication, Moscow 1952.

Maria Lemnis, Henryk Vitry, *A Cookbook for the Lonely and the Lovers* [no cover or title page, no date or place of publication].

Maria Lemnis, Henryk Vitry, *In the Old Polish Kitchen and at the Polish Table*, Warsaw 1979.

Konrad Lorenz, *Conversations with Animals*, translated by Barbara Tarnas, Warsaw 2014.

Antoni Słonimski, *Reality and Daydream*, Warsaw 1966.

Yuri Trifonov, *Time and Place*, translated by Janina Dziarnowska, Warsaw 1985.

Lyudmila Ulitskaya, *The Green Tent*, translated by Jerzy Redlich, Warsaw 2013.

Wiktor Woroszylski, *Cyryl, Where Are You?*, Warsaw 1962.

Maria Zientarowa, *Small Fry*, Warsaw 1980.

An English-language textbook, no cover or title page, no author, date or place of publication.

And many others.

The piece about paper and the eighties (pages 26–28) was published in the column 'Papers and people', *Gazeta Wyborcza*, 24 October 2016. I wrote about the history of the ballpoint pen in 'The pariah of design', *Viva Moda*, 2015, no 3. I used the text by Włodzimierz Kalicki entitled 'I like big money, a conversation with Andrzej Heidrich, banknote designer', *Gazeta Wyborcza*, 27 September 2004, Wyborcza.pl [accessed 2 February 2017].

'My Mother's Kitchen' is the title of a poem by Lucjan Szenwald (1909–1944).

I am grateful to my mother's friends. They never left her side. I'd like to thank those who shared their memories with me (I took the liberty of quoting one of them on page 89).

Our Lady of the Nile
Scholastique Mukasonga
Translated by Melanie Mauthner

The Coming Bad Days
Sarah Bernstein

Filthy Animals
Brandon Taylor

The Breaks
Julietta Singh